# MEDIEVAL NAPLES
## AN ARCHITECTURAL & URBAN HISTORY 400–1400

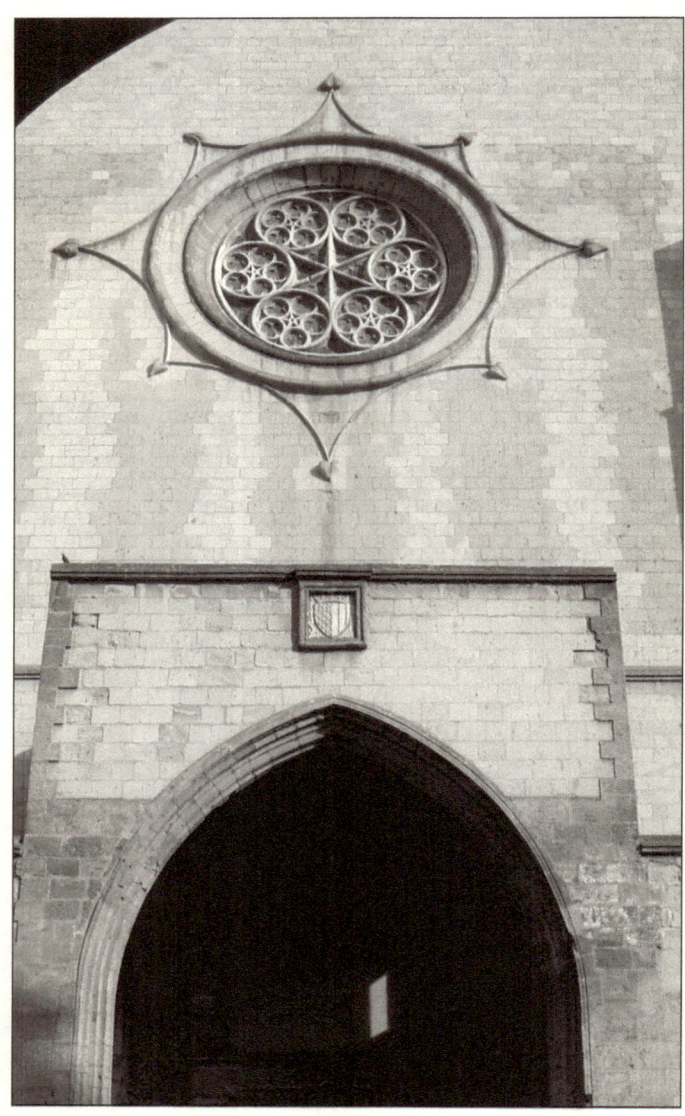

*Sta. Chiara, portal facade.*

# MEDIEVAL NAPLES
## AN ARCHITECTURAL & URBAN HISTORY 400–1400

BY
CAROLINE BRUZELIUS
& WILLIAM TRONZO

PREFACE BY
RONALD G. MUSTO

ITALICA PRESS
NEW YORK
2011

Copyright © 2011 by Caroline Bruzelius & William Tronzo

A Documentary History of Naples Series
Medieval Naples, 400–1400

ITALICA PRESS, INC.
595 Main Street, Suite 605
New York, New York 10044
inquiries@italicapress.com

All rights reserved. No part of this publication may be reproduced, stored in a retrieval system, or transmitted, in any form or by any means, electronic, mechanical, photocopying, recording, or otherwise, without prior permission of Italica Press. It may not be used in a course-pak or any other collection without prior permission of Italica Press.

**Library of Congress Cataloging-in-Publication Data**

Bruzelius, Caroline (Caroline Astrid), 1949-
  Medieval Naples : An Architectural & Urban History, 400–1400 / by Caroline Bruzelius & William Tronzo.
    pages cm -- (A Documentary History of Naples Series)
  Includes bibliographical references and index.
  Summary: "Forms a comprehensive and illustrated survey of the art and architectural history of Naples in the Middle Ages, while reviewing the development of Naples and its chief monuments, urban fabric and topography"--Provided by publisher.
  ISBN 978-1-59910-202-3 (hardcover : alk. paper) -- ISBN 978-1-59910-203-0 (pbk. : alk. paper) -- ISBN 978-1-59910-204-7 (e-book)
  1. Art, Medieval--Italy--Naples. 2. Art, Italian--Italy--Naples. 3. Architecture, Medieval--Italy--Naples. 4. Naples (Italy)--Buildings, structures, etc. I. Tronzo, William, 1951- II. Title.
  N6921.N2B78 2011
  709.45'7310902--dc22
                                                                 2010045912

Cover Image: The Pietrasanta (Sta. Maria Maggiore). Photo: Italica Press.

FOR A COMPLETE LIST OF ITALICA PRESS TITLES
VISIT OUR WEB SITE AT:
WWW.ITALICAPRESS.COM

# CONTENTS

| | |
|---|---|
| List of Illustrations | vi |
| Preface | ix |

## Chapter 1: Naples in the Early Middle Ages by William Tronzo

| | |
|---|---|
|  | 1 |
| *"Portusque et litora mundi hospita":* | |
| The Material Form of the Early Medieval City | 1 |
| Catacombs | 12 |
| Sta. Restituta and the Stefania | 24 |
| San Giovanni in Fonte | 32 |
| The Early Development of the Medieval City | 41 |

## Chapter 2: Naples in the High & Late Middle Ages by Caroline Bruzelius

| | |
|---|---|
|  | 49 |
| Religious Foundations and Urban Topography | 49 |
| The Patronage of Pious Confraternities, the Angevins and the Churches of the Friars | 62 |
| Tuscan Artists in Naples | 80 |
| Naples Becomes a Capital | 84 |
| The Angevin Reconfiguration of the City | 98 |

## Bibliography

| | |
|---|---|
|  | 115 |
| General and Multiperiod | 115 |
| Late Antiquity | 117 |
| The Ducal Period | 118 |
| The Normans | 118 |
| The Hohenstaufen | 119 |
| The Angevins | 119 |

## Online Resources 124

## Appendices

| | |
|---|---|
| The *Tavola Strozzi* | 126 |
| Map of Medieval Naples | 128 |
| Alphabetical Key to Map with Thumbnail Images | 130 |

## Index 135

# ILLUSTRATIONS
*Photos by Italica Press unless otherwise indicated.*

| | |
|---|---|
| Frontispiece. Sta. Chiara, portal facade. | ii |
| 1. Castel dell'Ovo, refectory of the monastery of San Salvatore. | xv |
| 2. San Giorgio Maggiore, ambulatory. | xvi |
| 3. Topography of the Bay of Naples. Source: Google Map. | 1 |
| 4. Siege of Naples: from Peter of Eboli, *Liber ad honorem augusti*. Bern Burgerbibliothek 120 II. | 3 |
| 5–6. Remains of the Greek Walls at Piazza Calenda (5) and Piazza Bellini (6). | 5 |
| 7. The Greek grid of *plateiai* and *stenopoi*. From the Duca di Noia plan. | 6 |
| 8. The Temple of the Dioscuri, now San Paolo Maggiore. Francesco d'Olanda, c.1540. | 7 |
| 9a. Reconstruction of the Temple of the Dioscuri (L) and Macellum (R). Museo di San Lorenzo | 8 |
| 9b. Axiometric reconstruction of Forum area with Odeon (theatrum tectum, A), Theater (B), Temple of Dioscuri (C) and Macellum (D). Museo di San Lorenzo | 8 |
| 10. Remains of the Villa Lucullana and monastery of San Salvatore. | 9 |
| 11. Central hall of the upper catacomb of San Gennaro. Print by C.F. Bellerman, Hamburg, 1839. | 13 |
| 12. Catacomb of San Gennaro, general plan. From Fasola, *Le Catacombe*, Plan 1. | 14 |
| 13. Catacomb of San Gennaro, upper complex, central gallery. From A. De Jorio, *Guida per le Catacombe di San Gennaro*, tav. II. Naples, 1839. | 15 |
| 14. North-South section of 1971–73 excavations. Fasola, fig. 80, p. 114. | 16 |
| 15. San Gennaro, oldest known image. Fasola, Tav. VII, opposite p. 92. | 17 |
| 16. Bishop Quodvultdeus of Carthage. Fasola, Tav. XII, a. | 18 |
| 17. Family of Ilaritas and Theotecnus. Fasola, Tav. 5, a. | 19 |
| 18. Cathedral, Chapel of San Gennaro, dome. | 25 |
| 19. Cathedral, plan with Sta. Restituta (left). De Stefano, 1974. | 26 |
| 20. Sta. Restituta, nave. | 27 |
| 21. Episcopal insula. From R. Farioli, *L'Art dans Italie méridonale*. | 28 |

## ILLUSTRATIONS

22. Sta. Restituta, apse. Figure of Christ. 30
23. San Giovanni in Fonte, mosaic program.
    From J. Wilpert, *Die römischen Mosaiken und Malereien der kirchlichen Bauten vom IV bis XIII Jahrhunderts*. Freiburg-im-Breisgau, 1916. 33
24. San Giovanni in Fonte, the *Chi Rho*. 34
25. San Giovanni in Fonte, the *Traditio Legis*. 35
26. San Giovanni in Fonte, figures holding crowns. 36
27. San Giovanni in Fonte, Samaritan Woman at the Well. 38
28. San Giovanni in Fonte, St. Matthew. 40
29. San Giovanni in Fonte, the Lion. 40
30. Macellum at San Lorenzo Maggiore. 42
31. San Lorenzo Maggiore, early Christian basilica in its archaeological context. Museo di San Lorenzo. 42
32a–b. San Paolo Maggiore. 44
33. Sta. Maria Maggiore, campanile (Pietrasanta). 45
34. Pietrasanta, south elevation. Photo: William Tronzo. 47
35. Sta. Chiara, cloister gallery. 48
36. Detail of Duca di Noia plan: San Lorenzo and cathedral. 50
37. Detail of Duca di Noia plan: San Giovanni a Mare and Sant'Eligio. 51
38. Detail of Duca di Noia plan: Castel Nuovo and Sta. Chiara. 53
39. Palazzo Penna. 54
40. Palace of Prince Philip of Taranto. 54
41. San Giovanni a Mare, view of the nave. 57
42. Cathedral, the vault of the tower of 1233. Photo: Caroline Bruzelius. 60
43. Caserta Vecchia, the tower of 1234. Photo: Caroline Bruzelius. 61
44. Sessa Aurunca, west porch of the cathedral. Photo: Caroline Bruzelius. 63
45. Sta. Maria del Carmine, plan. Archivio di Simancas. 67
46. Sant'Eligio al Mercato, hypothetical reconstruction of construction phases. Caroline Bruzelius. 68
47. Sant'Eligio al Mercato, view of nave & transept. 69
48. Sant'Eligio al Mercato, west portal. 70
49. Detail of Duca di Noia plan: Sta. Maria la Nova. 71
50. San Lorenzo, hypothetical reconstruction of construction phases. Caroline Bruzelius. 72
51. San Lorenzo, view of nave toward the chevet. 73

52. San Lorenzo, west wall of south transept with
    fragments of Nativity fresco. Photo: Giovanni Genova.   76
53. San Lorenzo, east wall of south transept with
    fragments of Dormition fresco. Photo: Giovanni Genova.  77
54. San Lorenzo, tomb of Catherine of Austria.   78
55. San Lorenzo, detail of nave wall. Photo: Caroline Bruzelius.   79
56. San Domenico, view of the interior.   81
57. San Domenico, the main portal.   82
58. Sta. Chiara, tomb monument of Robert of Anjou.   83
59. Sta. Maria Donnaregina, the nuns' choir.   85
60. Cathedral, reliquary head of San Gennaro.
    Archdiocese of Naples.   87
61. Cathedral, plan. De Stefano, 1974.   89
62. Cathedral, piers at the northwest end of the nave.
    Photo: Massimo Velo.   90
63. Cathedral. Minutolo Chapel, overview.   93
64a–b. Cathedral, Minutolo Chapel. Photos: Giovanni Genova.   94
65. Sta. Maria Donnaregina, plan and elevation.
    From Venditti, in *Storia di Napoli* 3, Piante e Rilievi.   96
66. Sta. Maria Donnaregina, apse. Photo: Massimo Velo.   97
67. San Pietro a Maiella, view of the interior.   99
68. Sta. Chiara, view of the interior.   101
69. Sta. Chiara, plan. Dell'Aja, 1980.   103
70. Sta. Chiara, nuns' choir toward the altar.   103
71. Tomb of Sancia of Majorca. Seroux D'Agincourt.   105
72. San Giovanni a Carbonara, tomb of King Ladislao.   107
73. San Giovanni a Pappacoda, facade.   108
74. Sta. Maria Incoronata, west elevation.   109
75. Sta. Maria Incoronata, nave.   110
76. Sta. Maria Incoronata, loggia.   111
77. Castel Nuovo, triumphal arch of Alfonso I.   113
78. Sta. Maria Donnaregina, tomb of Mary of Hungary.   114
79. Sta. Maria Incoronata, loggia, springing of arches.   134
Thumbnails   130–33

■

# PREFACE

We are pleased to present the following book as part of Italica Press's *Documentary History of Naples*. This volume is intended as a general, though rigorous, introduction to the monuments and urbanism of Naples in the Middle Ages. It offers one of the few introductions to the overall topic available in English for general readers, students or scholars unfamiliar with the history of the city. As such it makes a valuable contribution to the field and our understanding of its current status and issues. Caroline Bruzelius and William Tronzo, both distinguished art historians of the Middle Ages with special expertise in Naples and southern Italy, have contributed the following chapters on the medieval city's art, architecture and urbanism.

William Tronzo's chapter begins with the end of the western Roman Empire, an artificial milestone that can be assigned to Naples with the forced abdication of Romulus Augustulus to the Ostrogoth Odoacer at the Castrum Lucullanum in 476 CE. It concludes with the end of the duchy in 1139. Tronzo covers a range of topics, including the material form of the late ancient and early medieval city, the catacombs, the early cathedral complex — including Sta. Restituta and the Stefania — San Giovanni in Fonte (the baptistery) and the early medieval development of the city itself.

Caroline Bruzelius then picks up the narrative and analysis from the twelfth century to the end of the Angevin period, or the mid-Quattrocento. She revisits some of the same material on the early medieval city from a different perspective, that of religious foundations and urban topography. She next proceeds to patronage — that of individuals, confraternities and the various

ruling dynasties — and then moves on to the role of Tuscan artists in Naples, concluding with the Angevin reconfiguration of the city in the late Middle Ages. The focus on religious institutions requires repeated consideration of the ancient urban grid, its constraints upon building sites and forms and the political, religious, cultural and material factors that influenced the arts in the city during the Middle Ages.

Several themes emerge from these analyses that are worth noting here. The first is the lack of continuity of major structures from late antiquity. While we know the general location of the Roman buildings, few traces remain of the forum complex, the hippodrome, stadium, theaters, walls and port. What survive are only the imprints of the great Constantinian basilicas that formed the core of Naples' religious topography and that emerged from late antiquity and through the rebuilding programs of subsequent centuries. Many smaller structures of late antiquity — for example the seven *diaconiae* built between the duomo complex and the ducal palace or *praetorium* (also lost) — have either disappeared or been modified beyond recognition.

Indeed, given the fractured and discontinuous survival of the material culture of Naples, the ancient grid emerges as one of the few continuous elements of the city's history. As both Tronzo and Bruzelius make clear, atop its clearly delineated tufa platform, first built upon by the ancient Greeks, Naples continued to live within its rigid — if ever renegotiated — cardo-decumanus *(stenopos-plateia)* grid plan. Upon this plan and within its ancient and famed walls, the city's urban core remained (and remains) virtually unchanged. Expansions, when they were made, came outside this core — *extra moenia* — and

PREFACE

substantive expansions to the walls came only at the end of the Middle Ages and off the central grid and platform.

A third important theme is the remarkable survival of late Roman and Byzantine urban institutions into the early twelfth century (and beyond) when the Normans incorporated the city into their kingdom. Here we would highlight the city's role as *civitas*: the seat of a bishop and of a Roman governor (Byzantine count and later duke). Of equal importance are the roles of the *nobiles* in its governance and of late Roman administrative offices and courts that certainly evolved over the course of the duchy but that retained their ancient titles and lineage. This continuity was made manifest by the highly self-conscious Latino–Greek culture of the city's elite and supported by Naples' ongoing role as a commercial center of the Mediterranean. More than perhaps any other center of late imperial Italy, with the possible exception of papal Rome, Naples thus remained a late antique city in form and function.

The following chapters will also reveal both the concerns and methods of recent art-historical investigation, most clearly in their discussions of several varied interpretations of well-known monuments. Examples cited by Tronzo include the art-historical discussions around the baptistery and the duomo complex of the early Middle Ages. Bruzelius' analysis of the impact of foreign styles and individual artists on the cultural life and fabric of the later medieval city, most prominently the role of French influence on the city's ecclesiastical architecture, offers another example.

Finally worth mention are current trends in methodological approaches to the city and its art history during this period. These would include both physical and textual records. In the first case this involves the increased

importance of archaeological evidence from recent excavations around the city (largely due to the extension of the *Metropolitana* transit line) noted by William Tronzo. The second concerns the availability or scarcity of textual evidence. Aside from references to the city's status, its defense and its urban description in medieval narrative sources, Naples' historical record has suffered the well-known and documented destruction of its archives across the centuries. However, a great deal of material survives in the form of previously edited collections that happily are now available either though massive (if sometimes imperfect) digitization programs of print resources, or through the careful reassembly and online curation of digital archives, such as the ALIM project (http://www.uan.it/Notarili/alimnot.nsf).

The construction of any narrative presumes continuity. In Naples, however, this is an almost impossible task, given the discontinuous and fragmentary nature of the evidence. Nevertheless, these essays do offer a comprehensive survey of medieval Naples' urban and architectural history and many fresh insights into its interpretation and presentation.

These chapters are accompanied by eighty-three illustrations, a keyed reproduction of the *Tavola Strozzi,* a map keyed with sixty thumbnail images, a list of Italica Press online galleries with over 450 additional color images, a list of online readings from Italica Press's *Documentary History,* and an index. The select bibliography is subdivided by period for the convenience of students and non-specialists. Full bibliographies — with ongoing supplements — are available online and for download at http://www.italicapress.com/index346.html.

■

# PREFACE

The publication process of this volume has been highly collaborative. Its two authors have been involved in the planning, discussion and implementation of *A Documentary History of Naples: Medieval Naples, 400–1400* since its inception over a decade ago. For its companion volume, Eileen Gardiner, a medievalist and literary scholar, is in the process of assembling readings and introductory materials on the textual culture of the city; and Ronald G. Musto is contributing materials and introductions to its religious, political and socio-economic history. These literary and historical contributions are now being assembled online as an open-access resource for use, discussion and revision and will be further edited and presented in separate print and electronic formats. The online editions allow the user to view full-color images at many levels of resolution, to search and to follow hyperlinks to internal references and to external bibliography, resources and online image galleries.

This combination of publishing formats, disciplinary methods and perspectives on the same historical data has allowed us to take advantage of new digital media that provide a platform for sharing research results in anticipation of their final publication in print and electronic formats. This approach is especially important for the history of medieval Naples, an area of great richness and complexity and yet one little known outside of Italy and among European specialists. In North America it remains an emerging field and one requiring an ever-expanding circle of studies and forms of publication, from the most specialized to more general treatments. It is our hope that this variety of forms will allow this work to reach as broad an audience as possible and to open up

to its readers a little discussed and even less understood city and its cultural richness and significance.

∎

The authors and editor would like to thank Prof. Joseph D. Alchermes of Connecticut College; Dottoressa Daniela Giampaolo of the Ministero per i Beni e le Attività Culturali, Soprintendenza Speciale per i Beni Archeologici di Napoli e Pompei; and Dottori Antonio Carpenito, Rita Ligouri and Antonio Di Maio of the Attività Tecniche di Supporto di Napoli.

Ronald G. Musto, Series Editor
*A Documentary History of Naples*
New York City, December 2010.

∎

**A Note on Online Resources:**

***Interactive Map:*** *The marginal note, "See Interactive Map," refers to this URL: http://www.italicapress.com/index287.html. See also below, p. 124; and a print copy of this map (pp. 128–29) with a thumbnail image key on pp. 130–33.*

***Web Galleries:*** *These are found on the appropriate locations in the page margins with the reference: "See web gallery...." The URL for each site is derived by taking the Italica Press Gallery URL (http://gallery.mac.com/rgmusto) and adding the specific site number. (See also p. 125 below.) Thus, for example, the URL for the Castel Capuano web gallery is: http://gallery.mac.com/rgmusto#100255. Or readers can simply go to the Italica Press Gallery home page and click into the appropriate site gallery.*

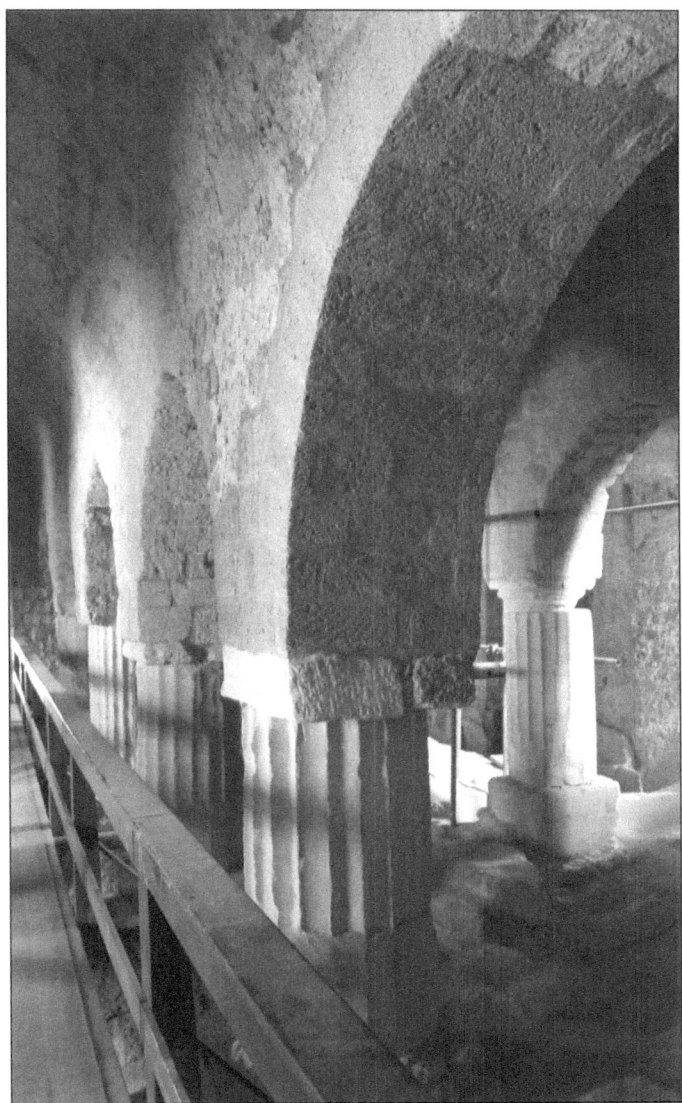

Fig. 1. Castel dell'Ovo, refectory of the monastery of San Salvatore.

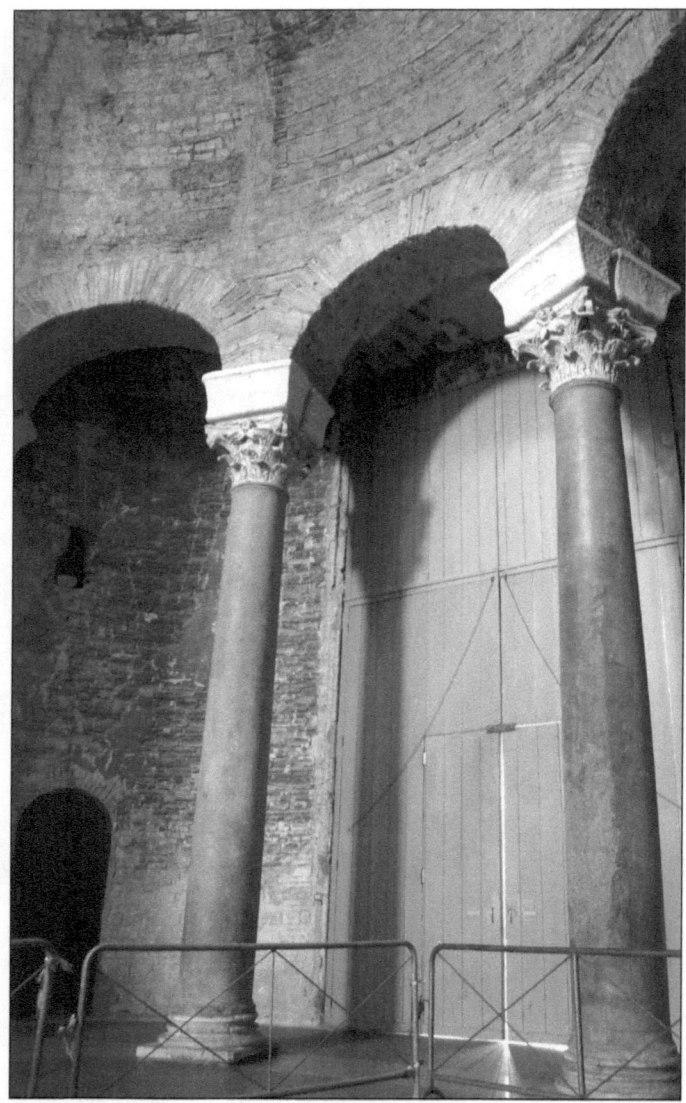

*Fig. 2. San Giorgio Maggiore, ambulatory.*

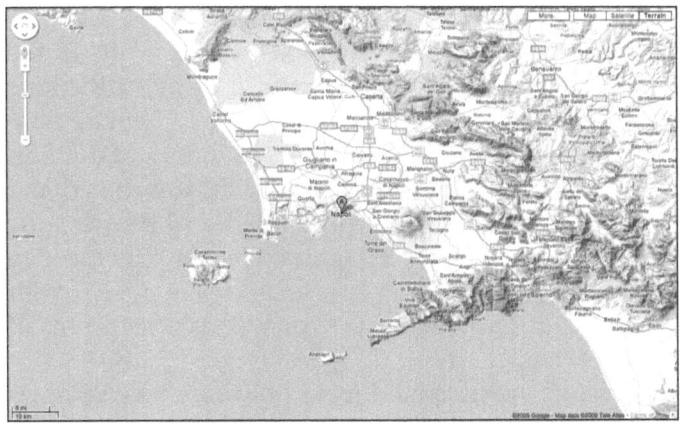

*Fig. 3. Topography of the Bay of Naples.*

# CHAPTER 1:
# NAPLES IN THE EARLY MIDDLE AGES
by William Tronzo

*"Portusque et litora mundi hospita"*[*]:
*The Material Form of the Early Medieval City*

[*] Statius, *Silvae* III.5, 75f.

Much of what nature offered the city of Naples from the very beginning was beautifully benign: a climate as stimulus to agriculture and the economy, access to the sea, a central vantage point on the Mediterranean as a whole, and an abundance of building material in the tufaceous substrate and pozzolana laid down by centuries of volcanic activity that formed the Neapolitan plain [Fig. 3]. Only the occasional turbidity of Vesuvius was the reminder of a threat that also lurked here: the danger of earthquakes and volcanic eruptions. But it was surely in no small part nature's beneficence that prompted a

cohort of Cumaean Greeks, in the great age of colonization, to found a city on the hill of Pizzofalcone in the seventh century BCE. They named the city Parthenope in honor of the legendary siren of the Sorrentine peninsula. At the end of the sixth or beginning of the fifth century BCE, the "old city" (*Palaiopolis*) was joined and then eclipsed by a new one positioned on the lower lying land to the east, *Neapolis*: Naples. The new city came to be organized on a Hippodamean grid plan. It grew with the influx of Cumaean Greeks as well as contingents of Samnites and others.

<small>See Interactive Map.</small>

Through a series of judicious political moves, Naples thrived in the era of Roman domination. Under the Gothic conquest of the first half of the sixth century CE, Naples became the seat of a count (*comes civitatis*). There then followed the Byzantine campaigns of Belisarius* and Narses, which opened the way to the establishment of a Byzantine duchy in the city under Emperor Constans II in 661/2. Naples eluded Lombard control and maintained its ties to Byzantium. But with the institution of hereditary succession by Duke Stephen II (755–66) in 755, in a dynasty lasting 75 years, and then again by Duke Sergius I (840–65) in 840, its affiliation with the East became increasingly attenuated. For all intents and purposes Naples became autonomous. Sergius' dynasty persisted 300 years, up to the time of the Norman conquest in 1139, through whom the city segued to the medieval empire and eventually to Angevin rule.

<small>* See Documentary History chap. 2, readings 536, 537, 537/8.</small>

∎

The subject of the following chapter is the material form of the early medieval city, which may be delineated by

a pair of questions: wherein lie the traces of this form and what can they tell us about the society that produced them? Given the relatively restricted scope of our publication, these are questions that we are constrained to engage only selectively. We have chosen to do so through the vehicle of certain monuments and themes we believe to be key. Our aim has been to balance coverage of the medieval period as a whole with a particularized look at buildings, sites and issues; thus we shall move continuously between the general and the specific. In this endeavor, we have benefited from the excellent surveys of medieval Naples in the *Storia di Napoli*, (volumes 1 and 2, 1967–69) and Paul Arthur's *Naples: From Roman Town to City-State*, as well as a number of more focused studies that have illuminated important aspects of the city in this period. It must be borne in mind that, while ancient Naples survives notably in its

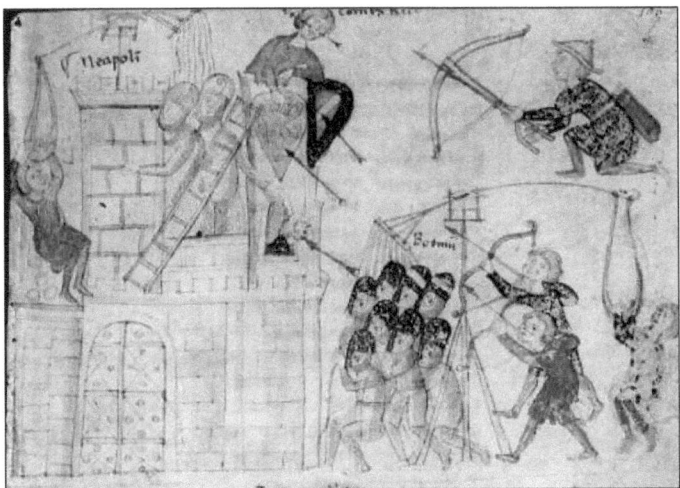

Fig. 4. *Siege of Naples: from Peter of Eboli*, Liber ad honorem augusti. Bern Burgerbibliothek 120 II.

grid plan and numerous *spolia*, the medieval city, after a brilliant beginning in Late Antiquity, has largely disappeared. It exists almost entirely in fragments, in the works of architecture, painting and sculpture that are often so disparate as to be incapable of merging with facility into a coherent narrative, and these too in some sense must be given their due.

Medieval Naples also exists in a few rare images of the city as a whole, both visual and verbal, which have come down to us from the hands of medieval contemporaries. On one side of the chronological spectrum is the late twelfth-century illustrated edition of the poem on the German emperor Henry VI by Peter of Eboli, the *Liber ad honorem augusti*, now preserved in the city library of Bern (Burgerbibliothek 120 II). In a scene of the siege of Naples, we see a massive fortification of royal prerogative that conveyed the true significance of the aggregation: as a protected place under the aegis of the ruler [Fig. 4]. Substantial additions, in fact, were made to the defensive works of the city for the first time since Late Antiquity by Henry's immediate predecessors, the Norman kings, including the building of the Castel Capuano by William I (1154–66).

See web gallery 100255.

Yet at an earlier point in time, the figure of the wall appeared to different effect. In an extended description in the life of Bishop Athanasius of c.875 cited by Chiara Frugoni in her evocative disquisition on medieval modes of representing the city, Naples is praised as "beautiful in all the constructions that defend it, beautiful for its outlying quarters, and for the religious piety of the Christians who dwell inside the walls" (Frugoni, 67). The fortifying wall here is merely the outward manifestation of the protective power of the spirit which, as

*Remains of the Greek Walls.*
*Fig. 5: Piazza Calenda.*
*Fig. 6: Piazza Bellini.*

Frugoni observes, is the true guarantor of the safety of the city. That this spirit takes shape in the multitudinous churches, shrines and tombs of Naples, *"antiquae videlicet et vetustissimae structurae,"* is a point also driven home by the text (Frugoni, 67). These sites, with a few exceptions, form the focus of the narrative that follows.

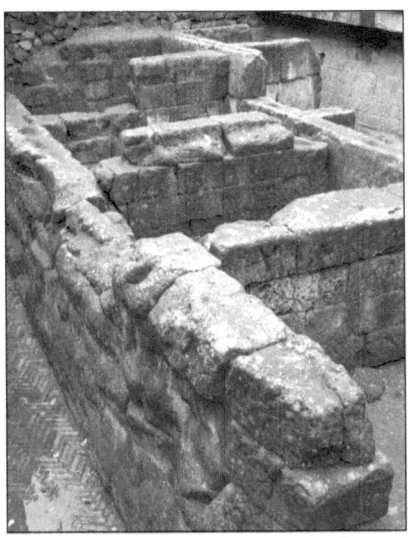

The salient framework of medieval Naples is the Greco-Roman city of Neapolis. Tracts of a fifth-century BCE fortification wall executed in massive ashlars, rebuilt and strengthened in the fourth and third centuries BCE, have been found at

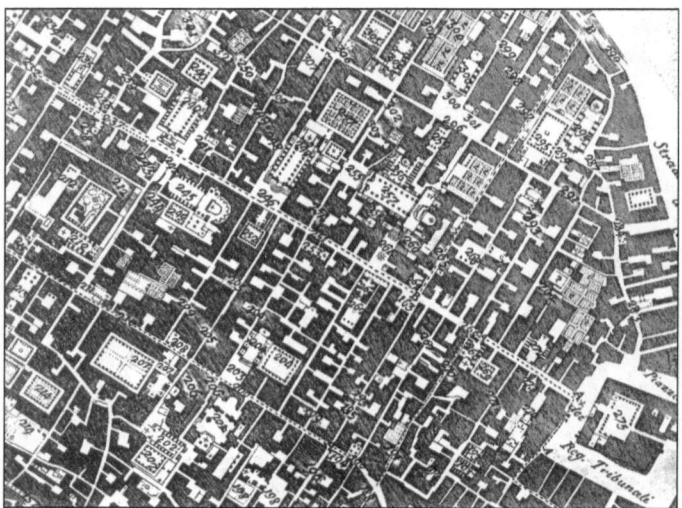

*Fig. 7. The Greek grid of* plateiai *and* stenopoi. *From the Duca di Noia plan.*

several locations in present-day Naples (such as the piazzas Cavour, Calenda and Bellini, Figs. 5, 6). These walls, punctuated at intervals by gates, inscribed a rectangular area that lay essentially between the Piazza Cavour and the port (north–south) and the via Carbonara and the via Costantinopli (east–west). The major internal divisions of the city consisted of three decumani (or *plateiai* in Greek) that ran east–west, still discernible in streets or portions thereof, such as the via Pisanelli and the via Anticaglia (upper decumanus), the via dei Tribunali (middle decumanus) and the via San Biagio dei Librai and the via Vicaria Vecchia (lower decumanus).

The decumani created four broad bands that were further subdivided into narrow rectangular blocks by twenty more-or-less evenly spaced cardines (also *vici* in Latin or *stenopoi* in Greek) running north–south [Fig. 7]. Near the center of the

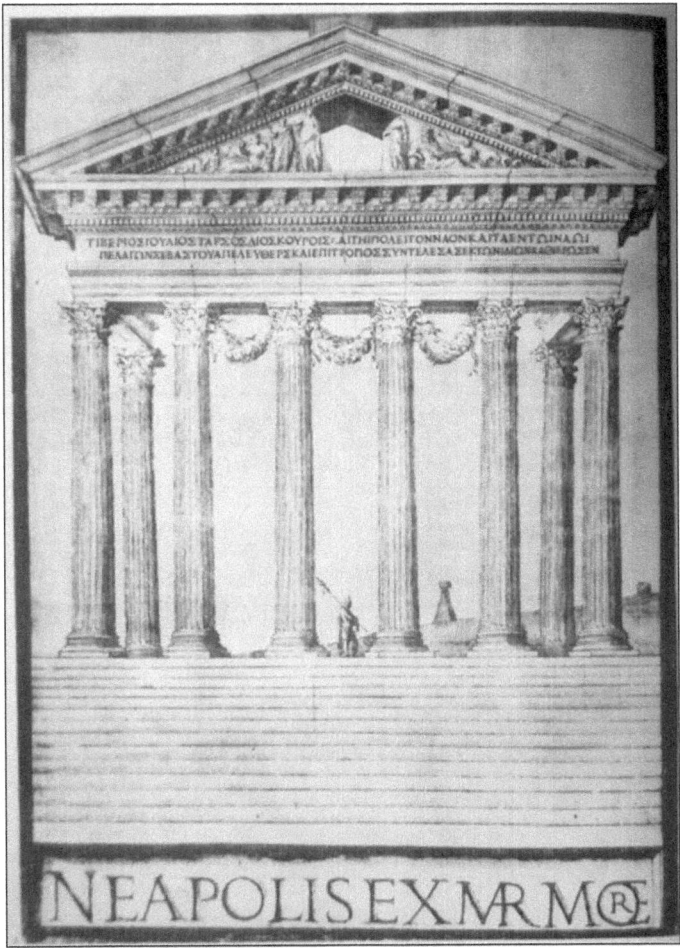

*Fig. 8. The Temple of the Dioscuri, now San Paolo Maggiore. Francesco d'Olanda, c.1540.*

grid stood the agora or forum dominated by the Temple of the Dioscuri [Fig. 8] (from the reign of the emperor Tiberius) whose facade, replete with sculpted pediment, was drawn

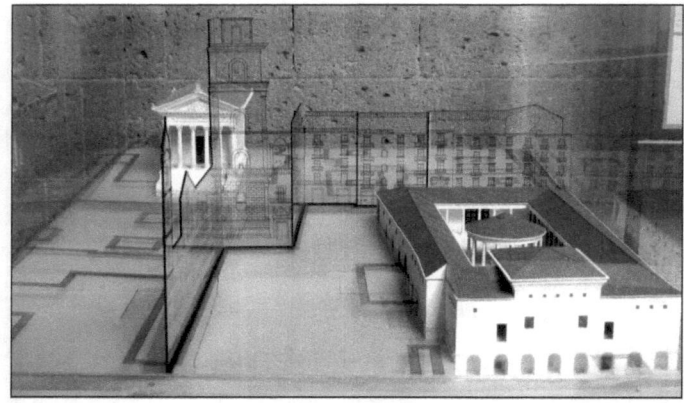

Fig. 9a (above). Reconstruction of the Temple of the Dioscuri (L) and Macellum (R).
Fig. 9b (below). Axiometric reconstruction of Forum area with Odeon (theatrum tectum, A), Theater (B), Temple of Dioscuri (C) and Macellum (D).

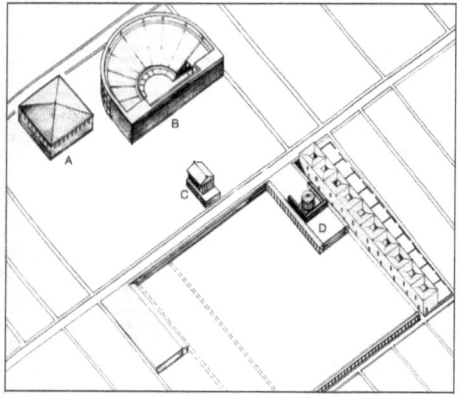

by Francesco d'Olanda c.1540. Its surviving portion, incorporated into the church of San Paolo Maggiore [See Figs. 32a–b], was almost entirely felled by an earthquake in the late seventeenth century. To the northeast lay the Odeon (*tectum theatrum*, A) Theater (*nudum theatrum*, B) and the Temple of the Dioscuri [Fig. 9a above, Fig. 9b: C]; to the northwest, the Temple of Apollo. Below the middle decumanus lay a macellum, whose tholos is now partly visible beneath the cloister of San Lorenzo Maggiore [Fig. 9b: D, Fig. 30].

Roman occupation expanded the Greek city beyond the grid. No doubt these additions *extra moenia* bled seamlessly into the suburbs that grew up around the city. Here arose a vibrant and original villa culture that made the city famous: *"otiosa Neapolis,"* in the words of Horace. The suburban residences that have been discovered by archaeologists beginning in the eighteenth century, or that live on in name, such as the villa of L. Licinius Lucullus [Figs. 1, 10] beneath the present-day Castel dell'Ovo, have fired the historical and aesthetic imagination. On the other hand, the evidence of domestic architecture from Antiquity within the walls is rare (mostly from excavations under churches, such as the Cathedral of Sta. Maria Assunta and San Lorenzo Maggiore). Although some evidence points to the existence of the multi-story apartment building, the *insula* (Arthur, 47), it seems clear that Naples never became a city of *insulae* like Rome and Ostia. Its urban fabric had been crafted before such a solution to the problem of high-density living had become the norm. As in Pompei, the denizens of the city must have lived primarily in the domus. It should also be borne in mind that Naples was never the site of a ruler's residence in Antiquity; and although it is to be assumed that palaces were built for both

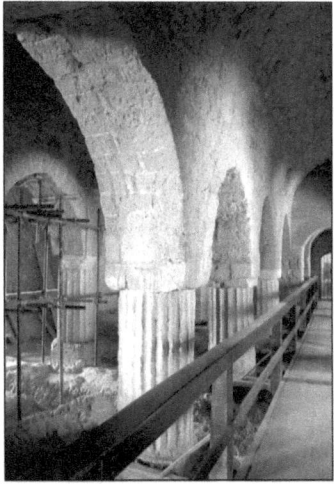

Fig. 10. Remains of the Villa Lucullana. Refectory of the monastery of San Salvatore.

See web gallery 100036.

ecclesiastical and civic officials in late Antiquity and the early Middle Ages, next to nothing about them is known.

Imperial gifts to the city included a gymnasium and baths (Titus) and a wharf (Septimius Severus and Caracalla); in addition, numerous inscriptions, altars, statues and other monuments of the Roman period have come to light. The ascendancy of the Roman state as well as the expansion of the metropolis rendered the ancient walls of Neapolis redundant, and although there is some evidence to indicate that they continued to be maintained under the imperium, they were also seriously compromised by the widening of openings, such as that undertaken to provide for an *adventus* of Emperor Nero. The situation changed dramatically in late Antiquity, particularly under Valentinian III (425–55), when the circuit was reinforced to meet the threat of invasion that dominated the fifth and sixth centuries. In an interpretation of the very scant remains, the walls of the city were expanded at this time to include the more populous suburbs; but this interpretation has been disputed (Arthur, 35–37).

Much could be said about the economic, social, religious and intellectual life of the city in Antiquity, but to stay on track it would be better to limit ourselves to one essential observation. Naples became the largest city of the Italian peninsula south of Rome, and it did so, unlike Rome, primarily by opening itself to, and absorbing, peoples and influences from the south, particularly Sicily, Malta, North Africa and the Greek East. In a poetic description of modern Naples, Walter Benjamin has employed the metaphor of "porosity" to characterize precisely this quality of the city vis-à-vis its milieu. The connections that have been made by scholars between works of ancient

(and medieval) art and architecture in Naples and these other areas of the world are vivid testimony to this fact. At the same time, Naples as an entity, an ethos, a collective project of the human spirit, had a sense of self strong enough to make of these disparate phenomena a world apart, and to strive to preserve the integrity of that world from generation to generation, often in the face of crushing change.

As a coda to this brief account, mention must be made of an extraordinary turn of events that has opened a new window onto the ancient and medieval city. In the course of preparing a subway line for Naples, Linea 1 of the *Metropolitana*, excavations have brought to light portions of the ancient and medieval city hitherto unknown. At the site of the Stazione Toledo, a field from the Neolithic period was uncovered, still preserving the pattern of furrows made by a plough. These ephemeral interventions were conserved by a protective layer of ash from a volcanic eruption that had settled into them. At the Stazione Municipio, three ships, two of which were purposefully sunk and one wrecked by a storm (including a rare example of a *horeia*, a type of vessel used for port service), were uncovered alongside the remains of pilings for the ancient port. The excavation has also enabled a more detailed reconstruction of the shifts and changes in the ancient and medieval coastline. At the Stazione Duomo, portions of three marble slabs of the late first century CE with lists of the names of winners of the Isolympic Games were discovered. The games, modeled on those of Olympia, were instituted by Emperor Augustus in 2 BCE in the city considered by many to be the most Hellenic on the Italian peninsula. The lists contain a selection of names mainly from Asia

Minor and Egypt in a number of categories of competition including one unique to Naples, a theater contest called the plasmati comedies. In the excavations for the Stazione Università, a warehouse complex of the seventh century CE was found. In the area of the Piazza Nicola Amore, twelfth-century workshops for the production of pottery and glass were discovered, in addition to the remains of an ornamental fountain of the early thirteenth century with a remarkable graffito of ships and a tower that has been identified as a portrait of the port of Naples. As a gift to the present-day citizens of, and visitors to, the city, and in advance of comprehensive publication, these sites and many of the objects associated with them are now on display in *Metropolitana* stations throughout the city.

## Catacombs

Tradition holds that Christianity took root in the bay of Naples with the arrival of the apostles Peter and Paul (in Naples and Puteoli/Pozzuoli respectively), and there is some tantalizing evidence of Christian habitation in the region in the form of inscriptions and images from the cities buried in the eruption of Vesuvius in 79 CE. But the material history of Christianity in Naples may be said to begin in earnest with a group of subterranean burial complexes, or catacombs, which were initiated in the second and third centuries. One normally associates the word "catacomb" with Rome, partly because the term derives from a specific place on the via Appia, *ad catacumbas* (at the hollows), where an ancient Christian burial ground was built, but more so because Rome contains a greater concentration of these structures than anywhere else. Catacombs were sculpted from the living rock, the tufaceous substrate of the Latium plain, and it

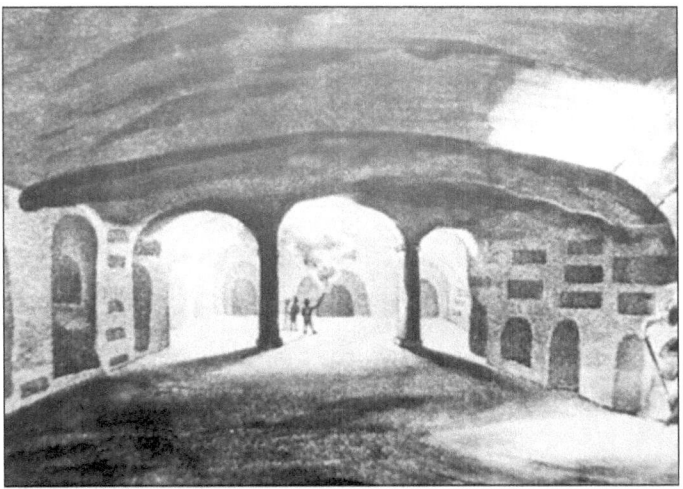

Fig. 11. Central hall of the upper catacomb of San Gennaro.
Print by C.F. Bellerman, Hamburg, 1839.

was precisely this material, tufa, that made them economically feasible. Tufa is easy to carve but hardens upon contact with air to the degree that it can render nearly permanent the sculpted forms. The Roman catacombs ringed the city, lining the roads that led in and out of it, in keeping with the prohibition against burial within the *pomerium*.

Likewise, the subterranean burial grounds of Naples, made possible also by the tufaceous substrate of the region, stood outside of the city (it has been speculated that they served an additional purpose as quarries for tufa blocks for above-ground construction). Notable among those known are: Sant'Eusebio (Sant'Efremo Vecchio), San Fortunato, San Gaudioso (Sta. Maria della Sanità), San Severo, and San Gennaro, the last, the largest, occupying a prominent position on the crest of Capodimonte. It is San Gennaro that demands the lion's share of our attention [Fig. 11]. Unlike the Roman catacombs, however, whose

*See web gallery 100331.*

decline began in the fifth century, San Gennaro remained accessible throughout the Middle Ages, serving for tombs as well as other important functions, including the defense of the city in the Second World War, which nearly led to its destruction.

The historical development of the site, charted by archaeologists, follows a known pattern, but only up to a point. (See the detailed and authoritative analysis of Umberto Fasola, from which this account is drawn.) Burials began at several locations, separate but in proximity to one another, mainly in small tomb chambers that were square in shape for individuals or families (*hypogea*). In the late second or early third century, however, a much

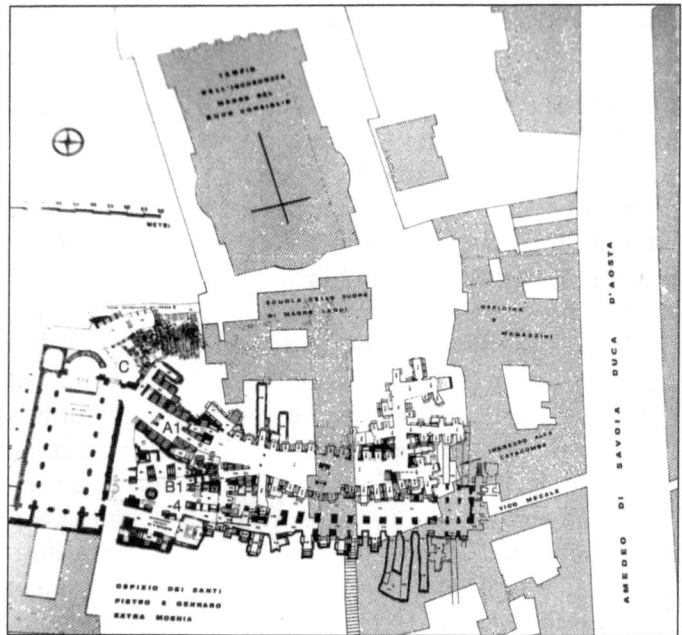

*Fig. 12. Catacomb of San Gennaro, general plan. From Fasola,* Le Catacombe, *Plan 1.*

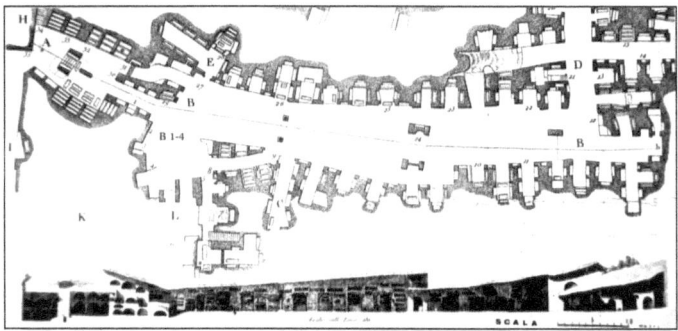

Fig. 13. Catacomb of San Gennaro, upper complex, central gallery. From A. De Jorio, Guida per le Catacombe di San Gennaro, tav. II. Naples, 1839.

larger space was opened up that extended southward to incorporate the remains of several pre-existing hypogea and northward to house three large, evenly-spaced tomb chambers [Fig. 12, 13, B1–4]. The large space, which was most likely devoted to funeral rites, was decorated with wall painting typical of the early third century: a trellis-like scheme of red and yellow lines on a white ground filled with vignettes and motifs drawn from a bucolic repertoire. The fact that none of the images were clearly and unambiguously Christian may indicate that this was a non-Christian undertaking. At a slightly later point but still within the first half of the third century, another large space was excavated above the first and to the north [Fig. 12, A1]. It too consisted of a large room, again probably for funeral rituals (this time provided with a bench), with numerous *loculi* or shelf-graves. In this case, however, the ensemble was clearly Christian in affiliation as indicated by elements of the decoration. One of these elements, a scene of women and a tower, has been connected to an anonymous visionary text of the second century, the *Shepherd of Hermas*, written in Greek probably in Rome, lending the area, in turn, the name "regione Greca."

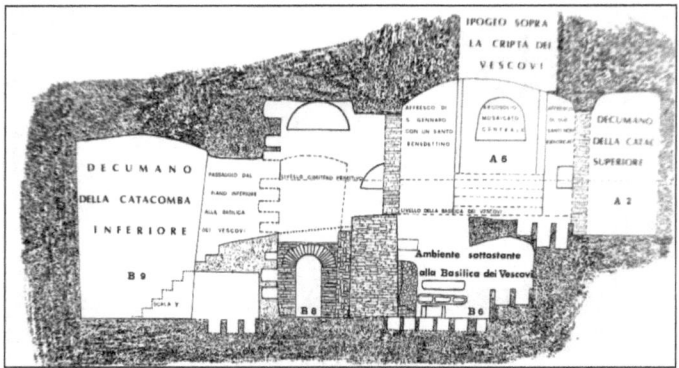

*Fig. 14. North-South section of 1971–73 excavations. Fasola, fig. 80, p. 114.*

These two spaces, the one to the south and the other to the north, were fundamentally determinative of the eventual shape of the catacomb and its division into upper and lower parts.

Today the catacomb stands in the shadow of the modern basilica dedicated to St. Januarius (Gennaro), after whom the burial ground is named. Januarius himself is a shadowy figure. Patron saint of Naples (September 19), donor of the miraculous blood that liquefies numerous times a year in a ceremony performed in the cathedral of Naples, Januarius is believed to have been a bishop of Benevento martyred during the Diocletianic persecutions of 305, whose mortal remains were brought to the catacomb by Bishop John I. John died during the Easter vigil in 432 and according to the *Chronicon episcoporum s. napolitanae ecclesiae* was then buried in a cubiculum where he had deposited the remains of St. Januarius (Fasola, 111). Capodimonte once possessed two basilicas in his honor, one, the basilica minor, formed out of the fabric of the catacomb in direct proximity to the cubiculum that most likely housed his remains [Fig. 12, C].

There has been some ambiguity as to the precise location of this burial but in a recent review of the evidence, both material and textual, Umberto Fasola has made the case for the location in the crypt-like space in direct proximity to a large room [Fig. 14, A6], the so-called "cripta dei vescovi," with eight *arcosolia* and ten *loculi* graves whose walls were once covered with an elaborate marble revetment. The arcosolia, each intended to contain a single burial, were outfitted with decorations in mosaic and painting (four in each medium) that provide an important clue as to the identity of their occupants. Each arcosolium contains the portrait of an ecclesiastical official in clipeus format, a dignitary of the church whose interment belongs to the fifth century in Fasola's estimation, thus post-dating the translation of Januarius but also clearly the direct result of it, in the sense that proximity to the body of the saint was the primary desideratum. Presumably the practice followed that of John I, but as a communal endeavor it finds parallel elsewhere in the Christian world, in Rome and North Africa.

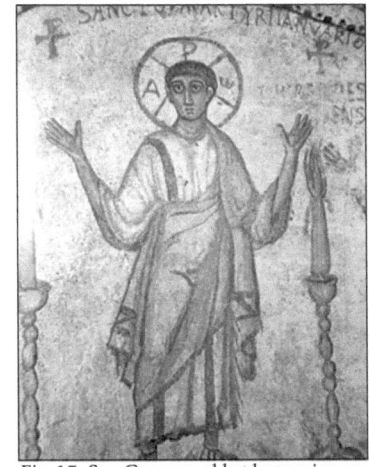

The portraits are hard edged and schematic yet still manage to convey the look and feel of an individual replete with wrinkles, sunken cheeks and thinning hair; in this sense they present a sharp contrast to the idealized image of St. Januarius, youthful and perfectly proportioned [Fig. 15],

*Fig. 15. San Gennaro, oldest known image Fasola, Tav. VII, opposite p. 92.*

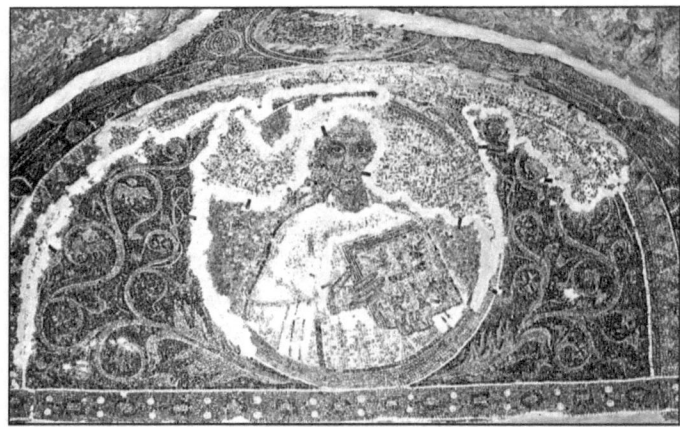

Fig. 16. Bishop Quodvultdeus of Carthage.

See web gallery 100331.

which occurs several times in the complex. One truly remarkable likeness in the crypt is the figure of a dark-skinned man of middle age. Fasola dates this image to the mid-fifth century and identifies its subject as the African refugee from the Vandalic invasions, Quodvultdeus, bishop of Carthage [Fig. 16], pointing out that Restituta and Gaudioso, honored elsewhere in Naples, were also of African origin. Links to North Africa are to be discerned in various decorative motifs, but so too are ties to Sicily, Malta, Ravenna and the East: the azure ground, the vine scroll and the ornamental pattern of interlocking circles in the arcosolium of Quodvultdeus, for instance, are distinctly reminiscent of the mosaic decoration of the Mausoleum of Galla Placidia in Ravenna of c.450.

One could easily become absorbed in the images with which the catacomb is so richly filled, but even a cursory survey would linger at one in particular, in the arcosolium of a family tomb (A23). In the lunette of the arcosolium, three figures with arms raised in prayer

solemnly staring forward, stand amidst pairs of burning candles: mother and father, Ilaritas and Theotecnus [Fig. 17], are depicted in half length beside their diminutive daughter, Nonnosa, the lower hem of whose himation brushes the beaded border of the lower frame. The daughter and father are as resplendent in dress as the mother is severe: bulbous pearls line the daughter's collar and form a diadem in her hair, and the father's (silk?) chlamys is decorated with leaping gazelles. The image gives us rare insight into a style of life. Members of the imperial courts in Ravenna, Milan and Constantinople would not have looked askance at these citizens of Naples, had they found them in their midst.

As Fasola observes, the introduction of the body of St. Januarius gave a prestige to the site that set it apart from the other burial grounds of Naples. A parallel phenomenon occurred in the lower zone of the catacomb, with the deposition of a third-century bishop of the city, Agrippinus, who was venerated as a saint. The presence

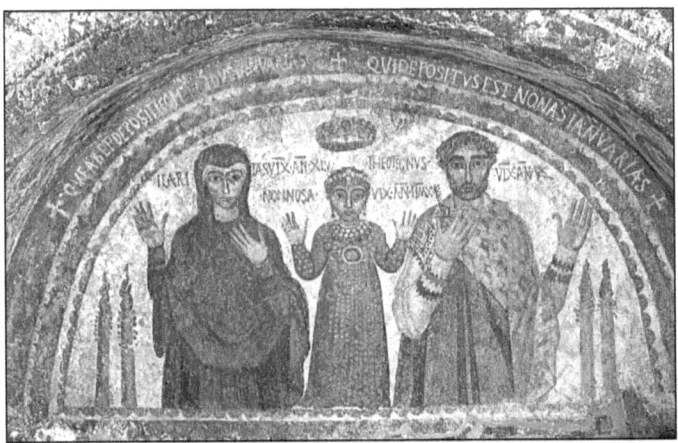

Fig. 17. *Family of Ilaritas and Theotecnus.*

of these holy bodies led to an enormous expansion of the catacomb, fueled by a desire that linked Theotecnus, Ilaritas and Nonnosa to the bishops of the Neapolitan and African churches: the desire to rest in perpetuity in the presence of a saint. The lower zone (with Agrippinus) was augmented in the fourth century with the addition of three large galleries that were extended into long corridors, off of which branched a number of other corridors at right angles, with cubicula and loculi (B8, B9 and B10 up to and including B67). From the tomb of the saint and the crypt of the bishops in the upper zone there opened, in the fifth century, a long, wide corridor that angled to the north, off of which extended another corridor to the north, lined with over three dozen spacious cubicula containing arcosolia tombs (A4, A41, A29, A45 and A60 up to and including A64). Thus the catacomb of San Gennaro flourished at a time when like endeavors in Rome were faltering. Burial in the Roman catacombs after the fifth century are rare. But not in the catacomb of San Gennaro.

Being outside of the walls of the city meant that the catacomb lay unprotected in times of strife, such as the Gothic wars of the sixth century and the Lombard invasions of the ninth. According to John the Deacon, Bishop John IV (842–49) transferred the bodies of the bishops from the catacomb to the Stefania (very possibly the restored early Christian edifice later known as Sta. Restituta) where he provided them with a new, monumental tomb structure. But the prize had already been lost. In 831 most of the remains of St. Januarius were taken to Benevento, and they remained outside of Naples until they were reunited with his head and blood in the cathedral in the late fifteenth century.

Yet burials of bishops and dukes in the catacombs of Naples continued at least up to the tenth century. According to the *Chronicon episcoporum*, Bishop Paul II (762–66) created a baptistery in the large space of the lower zone, B1, which had been turned into a vestibule with the addition of the corridor of tombs, B9. The foundation of the font still stands near the center of this space. The addition of a monumental, apse-like image of Christ in glory flanked by angels to an enormous light shaft inserted into the initial room of the upper zone, attributed by Fasola to the episcopate of Athanasius I (849–72), transformed the area into a liturgical space.*

*See web gallery 100331, Fig. 1.*

*\* See Documentary History chap. 3, reading 872.*

Clearly the Neapolitan church had great difficulty in relinquishing the catacomb, which, in the end, should give us something to ponder: is our modern designation, "catacomb," sufficient or even correct? "Catacomb" implies, above all, "tomb," and all that the tomb entailed; the monument of San Gennaro was clearly more than that. It served multiple and changing functions over the years in addition to inhumation and commemoration, embracing the present in a variety of manifestations that brought the Neapolitan community to Capodimonte in new and different ways. Perhaps it would be better to think about the catacomb of San Gennaro, therefore, more along the lines of an umbrella organization, a set of spatial opportunities based upon a pre-ordained scheme of late Antiquity, a virtual laboratory of ecclesiastical experiment, that was exploited in different ways at different times throughout the Middle Ages by the Neapolitan church. In this sense there is truly nothing comparable, not even in Rome.

It is our intention to remain within the city of Naples, but as a postscript to this analysis we should raise one final point and perhaps also only in the form of a question. Concurrently with the development of San Gennaro in late Antiquity occurred the emergence of another important arena for the veneration of a saint in the environs of Naples: in Nola, for St. Felix, under the sponsorship of the former Spanish bishop and recent transplant, Paulinus. At considerable personal expense Paulinus aggrandized the humble site that was Felix's tomb with a complex of buildings, including two basilicas, one which was rebuilt and the other built from scratch, whose decorations were described by him in letters that he sent to his friends abroad.

The fact that he disseminated this information is interesting. It is not at all typical of the day, but it seems in keeping with an innate predisposition of his that finds expression in other observations he makes, as for instance, on the crowds that thronged his shrines: "See how many from all parts come together and how they look wonderingly around, their rude minds piously beguiled. They have left their remote dwellings, they despised the hoar frost, not becoming cold because of the fire of their faith. And now, behold, in great numbers and waking they extend their joy over the whole night..." (Davis Weyer, 19).

The success of the site was the source of pride to Paulinus. Occurring as it did only slightly over a generation earlier than Bishop John I's intervention in the burial ground on Capodimonte, it must have set a kind of standard to be reckoned with, at least in its immediate vicinity, as Paul Arthur has suggested (64). Naples could not lay claim to a single ancient Christian hero of its

own; not one martyrdom occurred on its soil. But with Januarius, Naples came to possess a body of prestige. Yet it was not without effort since Januarius, presumably of Benevento, was taken, according to the text, from Marcianum near Puteoli: one wonders to what extent this effort was regarded as meaningful, if not essential, in the early-fifth century, to maintaining the status of foremost polity of the region. It is interesting to observe, therefore, that the oldest notice we possess as to the existence of the saint is to be found in the report of a vision Paulinus himself had days before his death, as Fasola has observed (Fasola, 111).

■

None of the other late antique Christian burial grounds of Naples possesses the complexity of San Gennaro: the catacomb of Sant'Eusebio, accessible through the church of Sant'Efremo Vecchio, contains only a few fragments of decoration; the catacomb of San Fortunato is now lost; the catacomb of San Gaudioso is accessible through the church of Sta. Maria della Sanità; and the catacomb of San Severo exists today in the form of a single cubiculum attached to the church of San Severo, which to some extent preserves, in the form of its crypt, the cemeterial basilica founded by Bishop Severus (c.468–508/10). There are a few notable images. The eponymous saint of San Gaudioso (sixth century) appears in a clipeus portrait (unfortunately now mostly lost) in a mosaic-encrusted arcosolium filled with a vine scroll. In his study of Neapolitan catacomb painting Hans Achelis placed this image directly in front of an illustration of the arcosolium of Heleudinius (fifth century) from the catacomb of San Gennaro, to

which it is closely similar. Also in the catacomb of San Gaudioso is the image of Pascentius in the lunette of the arcosolium containing his grave, shown striding toward St. Peter and another saint in a candle-lit room. In an arcosolium in the catacomb of San Severo, the deceased, presented as a diminutive office holder in a decorated chlamys, appears at the center of an apse-like composition flanked by Peter and Paul and two unidentified saints. What is lacking in these burial grounds is any trace of the imagery of salvation, the biblical narratives and bucolic themes that dominated the catacombs in the formative stages of the third and fourth centuries and that are to be found in the oldest chambers of San Gennaro. All of these images belong to the fifth and sixth centuries and to the genres of office-holding, ceremonial and portraiture, which reflect a religion firmly embedded in the habits and ideals of the ruling class.

## Sta. Restituta and the Stefania

The early history of the cathedral of Naples is fraught with ambiguity and unanswered questions, beginning with the involvement of the first Christian emperor, Constantine the Great. Constantine's interest in the city is not attested in the sources apart from the life of Pope Sylvester in the Roman *Liber pontificalis*,* which was compiled in the sixth century: *"eodem tempore fecit Constantinus Augustus basilicam in civitatem Neapolim"* ("At the same time Constantine Augustus built a basilica in the city of Naples"). Thus arose the tradition that he gave the city its first cathedral. But how likely is this? Constantine concentrated his church projects in the key locales of Rome, Palestine and

* See *Documentary History* chap. 2, reading c.500.

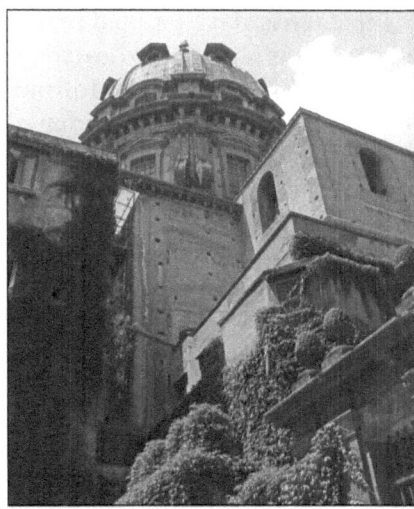

Fig. 18. Cathedral, Chapel of San Gennaro, dome.

Constantinople. Furthermore, he focused his attention on holy sites, the tombs of martyrs, such as Peter and Lawrence, and the places that marked major events in the life of Christ, such as his birth and burial. In the case of Constantinople, Constantine may or may not have founded the church that became the cathedral of the city, Hagia Sophia. But it is certain that he founded the Holy Apostles, in which he placed his own tomb. Regarding Rome, Richard Krautheimer has made the observation that Constantine's church building had the advantage of avoiding the center of the city, thereby lessening the risk of antagonizing the non-Christian ruling class. Naples does not fit the pattern with regard to the aforementioned, either in the importance of the site or indeed the city, or in the location of the church in a political–topographical sense. Is it possible that the Constantinian pedigree represents the attempt of a later history to adjust the past and give Naples the prestige of precedent equal to that of Rome?

The present-day cathedral of Naples, dedicated to Sta. Maria Assunta (but also referred to as San Gennaro), presides over the northwest quarter of the city from the

via del Duomo, with its immense nave flanked by the towering dome of the Baroque chapel dedicated to San Gennaro [Fig. 18]. The via del Duomo follows the line of an ancient *cardo/stenopos* (greatly widened in the late-nineteenth century), which crosses the middle *decumanus*, the via dei Tribunali. The building is an amalgam of structures begun in the late-thirteenth century; as such, it will be treated more fully at a later point.* It stands on the site of a number of buildings that formed the historic cathedral complex, two of which, in part, it incorporates off of the left side of the nave, Sta. Restituta and the baptistery, San Giovanni in Fonte.

* See below, pp. 88–94.

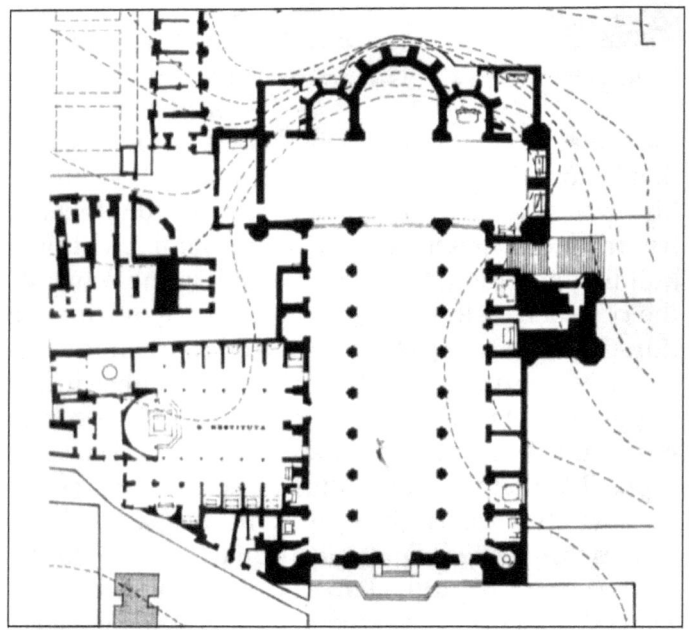

Fig. 19. *Cathedral, plan with Sta. Restituta (left). From De Stefano 1974.*

Fig. 20. Sta. Restituta, nave.

It is somewhat unsettling to move seamlessly through one church, the cathedral, into another, Sta. Restituta [Fig. 19], but such is the case with the present-day arrangement. Off of the outer wall of the north aisle of the cathedral opens the nave and aisles of the ancient church of Sta. Restituta [Fig. 20]. Restituta (May 17) was reputed to be an African maiden martyred in Carthage in the third or early fourth century (according to one account in the persecutions of Diocletian in 305), whose mortal remains were transferred in the eighth century, via the island of Ischia where they were deposited, to the church that was then re-dedicated to

her. The prior consecration may have been to the Holy Apostles and Martyrs (Arthur, 62), as well as to Christ.

What remains of the original edifice are six bays of a five-aisled nave (including what may be elements of a seventh bay, now immured), portions of the northern terminal wall and the main apse [Fig. 19]. Modern excavations have uncovered the foundations of a temple, identified as the Temple of Apollo, as well as a large domus, in addition to other structures, one of which has been identified as the

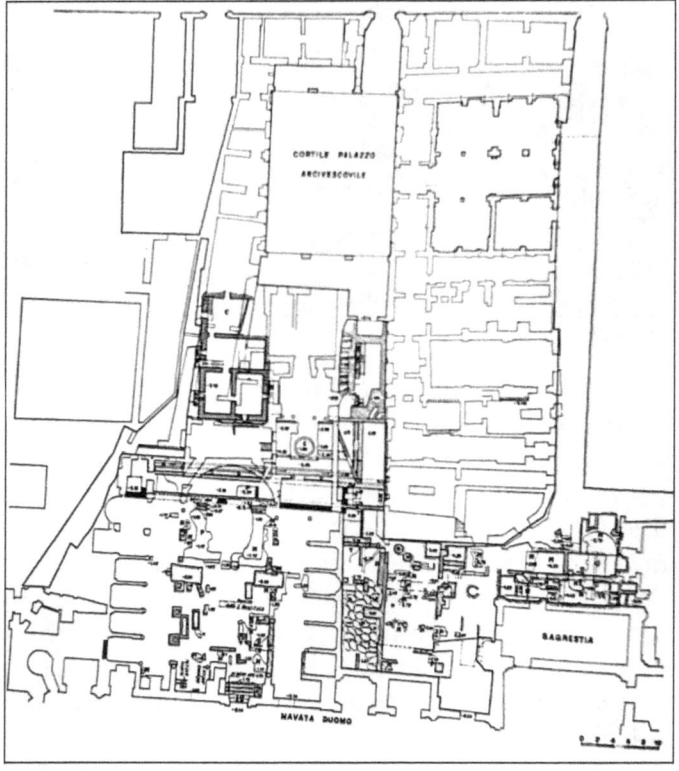

Fig. 21. *Episcopal insula.* From R. Farioli, L'Art dans Italie méridonale.

accubitum of Bishop Vincent, another as a baptistery, as well as others whose original uses are uncertain. The nave and aisle colonnades are formed from *spolia* that include matched sets of columns and Corinthian capitals carved from white marble. All of the wall surfaces and everything above the capitals of the colonnades is later revetment in stucco and paint, which, as a stentorian ensemble of gold and white, tends to overwhelm in its effect. The present-day experience of the church, in the abrupt juxtaposition of old and new, is quintessentially southern Italian; it is only with some effort of the imagination that the quieter and more muted form of the ancient structure emerges.

What impresses about the ancient building is the breadth of the space, the width of the nave and aisles and the expansiveness of the apse. Current research suggests that the original structure may not have been much longer than the present church and that it was preceded by an atrium that spanned the nave. It is in these proportions specifically, as well as in the staging of the apse — its raised floor and flanking columns — that connections to North Africa have been discerned. It is almost certain that the church was preceded by an atrium, the columns of which were re-utilized in the piers of the nave of the thirteenth-century cathedral. A basilica preceded by a large atrium would have been typical of early Christian churches in Italy and was a tradition maintained through the twelfth century in Campania. In addition, the remains of foundations thought to belong to the pulpit and ambo of the church have been found in the nave in the area of the third intercolumnation from the apse (Di Stefano, 142). If not Constantinian, the date for Sta. Restituta could hardly be other than fourth century.

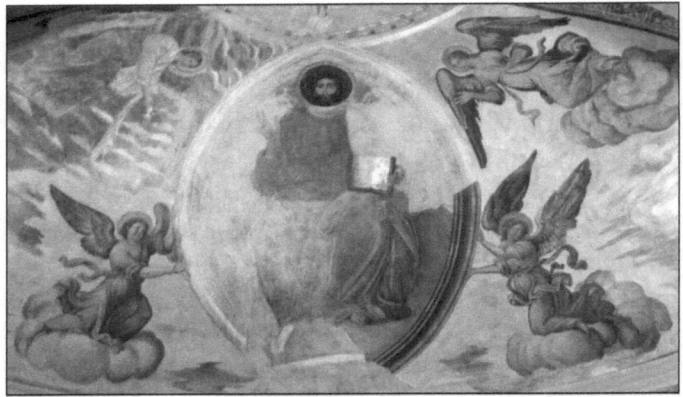

*Fig. 22. Sta. Restituta, apse. Figure of Christ.*

It may also have been the case that Sta. Restituta was the seat of the bishop of Naples, the cathedral of the city. To it accrued ancillary structures over the years [Fig. 21], including a bishop's residence, a granary, a hospital, a number of outlying chapels and two baptisteries, one of which will be discussed presently. A recent revelation is the decoration of the apse. The apse shows an obviously much altered image of Christ in glory flanked by angels [Fig. 22]. The image has a medieval core with a truly remarkable feature in the round panel that contains the head of Christ. Significant restorations of the apse occurred at the end of the sixteenth and again at the end of the seventeenth centuries, resulting in the reworking of the area surrounding the figure of Christ. But a portion of this figure, the flanking angel to the left, the evangelist symbols and the border, not to mention the round panel with Christ's head, are indisputably medieval; they have been dated by Pierluigi Leone de Castris, pending a full publication of the recent conservation work done in the apse, to the late eleventh or early twelfth century.

Leone de Castris situates the work in the context of the Desiderian reform of Montecassino; indeed the comparisons he makes with Sant'Angelo in Formis are compelling and so too the context that he adduces for the insertion of the portrait in the mural program (namely panels from Sant'Aniello a Caponapoli and the Chiostro del Paradiso in Amalfi). The practice of integrating panels in a mural program, however, also seems to have been more widely diffused.

According to the *Chronicon episcoporum*, at the end of the fifth or beginning of the sixth century Bishop Stephen I (499–504) built a church dedicated to Christ: *"fecit basilicam ad nomen Salvatoris, copulatum cum episcopio"* ("he built a basilica in the name of the Savior, connected to the bishop's palace"). A long and complicated historiographical tradition has actually credited Bishop Stephen with the creation of a new, second basilica thus called the Stefania. This interpretation has been contested (Lucherini, 2004 and 2009). The Stefania may have been the rebuilt fourth-century basilica, which later came to be called Sta. Restituta. Part of the confusion owes to the fact that, even though it is by the dedication to Sta. Restituta that the present edifice on the site is known today, both designations — the Stefania and Sta. Restituta — were used in the Middle Ages for one or more church buildings in the episcopal complex.

One insight into the early medieval form of the Stefania (possibly also Sta. Restituta) may be gleaned from the *Chronicon episcoporum*, which reports that a mosaic of the Transfiguration was inserted in the main apse of the edifice following a fire in the sixth century. According to the *Chronicon episcoporum*, Bishop Vincent (554–78) added a baptistery to the Stefania (*ad fontes*

*minores*), fragments of which may have been found in the excavations undertaken beneath the cathedral. Under John IV (842–49), the bodies of the bishops in the "cripta dei vescovi" in the catacomb of San Gennaro were removed to the Stefania where "he set in an arcosolium for each one of them, and above he painted their portraits" *(aptavit unicuique arcuatum tumulum, ac desuper eorum effigies depinxit.)*

The *Chronicon episcoporum* also states that the Stefania was *"copulatum cum episcopio,"* that is, "connected to the bishop's palace." Although the text employs the term *basilica* rather than *capella*, the positioning thus described seems almost one of deference. It is interesting to observe that the building subsequently came to house the remains of the ancient bishops of Naples taken from the catacomb of San Gennaro by John IV, in a monument built for them on which were also displayed their portraits. Given the fact that the catacomb was soon thereafter aggrandized by magnificent paintings whose purpose was to transform part of it into a liturgical space, it is difficult to see John's effort simply as one of preservation from an outside threat. The gathering up of the bodies of the ancient bishops together with the display of their portraits was a tangible contribution to the monumentalization of the office itself, which is in keeping with the building's physical linkage to the episcopal palace.

### San Giovanni in Fonte

*See web gallery 100398.*

This building is a miracle of preservation. It is constructed of brick and square in plan with a domical vault, and exquisite interior mosaics [Figs. 23–29]. It is first mentioned unambiguously in a chronicle of the thirteenth century. But according to the current consensus, it is a product of

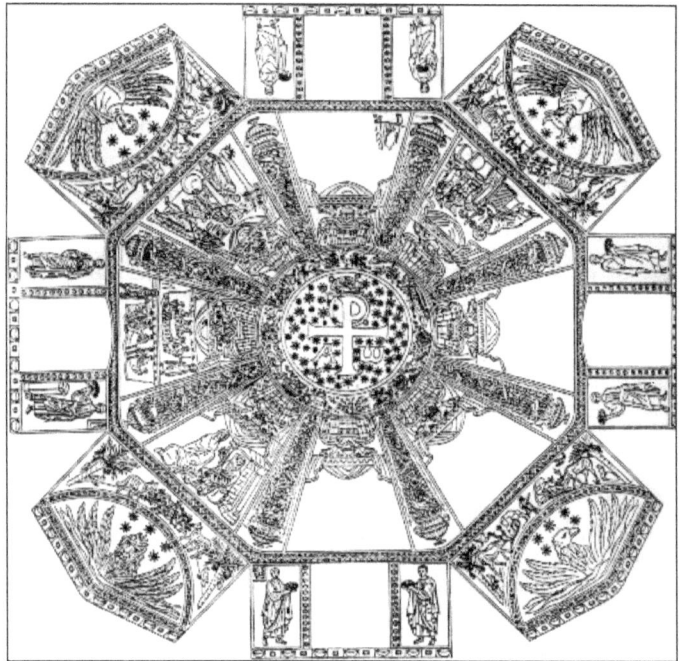

*Fig. 23. San Giovanni in Fonte, mosaic program. From J. Wilpert,* Die römischen Mosaiken und Malereien der kirchlichen Bauten vom IV bis XIII Jahrhunderts. *Freiburg-im-Breisgau, 1916.*

the patronage of Bishop Severus (c.368–408/10) in the early fifth century. The edifice is small, 7.6 m. on a side. Today it stands tucked into the northeast corner of Sta. Restituta, behind and to the right of the apse of the church. But it was once free-standing, like the baptistery of the Lateran Basilica in Rome (Di Stefano, 145). It is entered through a porch to the north, which is a later addition. The form of the original entrance has been discovered in a recent restoration. It consisted of two openings in the west wall, which was also pierced by a window, thus

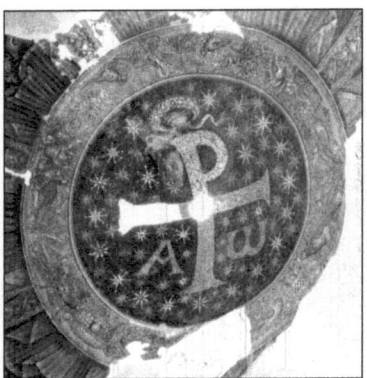

Fig. 24. San Giovanni in Fonte, the Chi Rho.

establishing the major axis of the building as east–west, not north–south as it is today. This is supported by the orientation of elements of the ceiling decoration, such as the monogram in the apex of the dome, as Jean Louis Maier has observed. In addition, there were windows in each of the other walls and the remains of a font in the center of the floor (Di Stefano, 145).

The square is transformed into an octagon in elevation by the insertion of angled apse-like vaults, squinches, into the four corners of the building above the cornice that forms the upper edge of the walls [Fig. 23]. The squinches are embedded in an eight-sided drum beneath the springing of the vault, which is marked by an ornamental border in mosaic. Mosaics are preserved only above the wall cornice. Even though several tracts of mosaic are missing, the overall program is clear.

The decorative concept may be called structural in the sense that the effort is made to demarcate and define wall and ceiling surfaces by the judicious use of ornamental border and frames. Thus the zone of the drum is divided into a set of four curved fields in the interior vaults of the squinches, four sets of spandrels above and in front of the vaults, and four panels, subdivided in turn, into three sections, in each of the areas contiguous with the walls. The vault itself takes the form of an octagon in its division into eight segments by tapering bands of leafy beribboned

branches held in vases. The medallion of the *Chi-Rho* (with a crown and the letters alpha and omega, Fig. 24) is surrounded by a wide border enclosing birds, including a phoenix, and flowers. The center of the vault is an oculus, or more accurately the illusion of one: the monogram seems to float on a dark blue background strewn with stars, at once the open night sky and a visionary plenitude. If one takes the background as key, as one is urged to do, then the decoration opens up also in the area of the squinch vaults, with their figures of the four beasts of Ezekiel and the Apocalypse. These too hover in the night sky as physical and spiritual visions. Seen in this way what is positioned above one's head in the baptistery in not simply closed wall and opaque surface, but a combination of open and closed space, demarcated by the broad bands of ornament that function like the slats of a trellis.

The trapezoidal compartments of the vault contained narrative scenes. What survive are the Women at the Tomb, the Miraculous Draught of Fishes and the Walking on Water, the *Traditio legis* [Fig. 25] and the Samaritan Woman at the Well [Fig. 27]. That these scenes were meant to be read as pictures, that is to say tableaux, and not as views to the outside like the starry night sky, is indicated by the

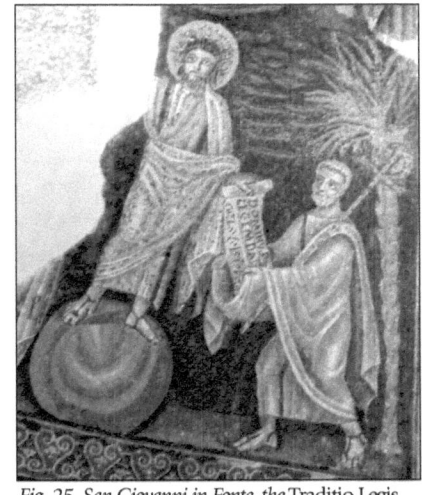

*Fig. 25. San Giovanni in Fonte, the* Traditio Legis.

*Fig. 26. San Giovanni in Fonte, figures holding crowns.*

curtains above them that seem to have been parted only too casually to reveal the precious images.

The wall zone contains panels, two on each side, with figures holding crowns [Fig. 26]. The various interpretations proposed by scholars over the years for these figures have been summarized by Maier, who opts for the identification of them as Apostles. According to Maier the four beasts in the vaults, or the four evangelists, complete the assembly, thus eliminating the awkwardness of the number eight for the figures (as opposed to twelve). This may well have been the case, but it is convoluted. The motif of the crown is reiterated in the central medallion above the monogram. The crown is a token of salvation. It is a symbol of the triumph over death. Christ *(Chi-Rho)*, having overcome death, is crowned. But the figures are not crowned; they hold crowns, and often in a way that suggests an offering. To whom? The logical recipient would be us, that is to say, those present in the baptistery about to experience the sacrament of Baptism and thus the promise of life that defeats death, which is what martyrs for the faith have already achieved. Most of the Apostles were martyrs, and it could be that these

figures represent the company of martyrs, irrespective of whether they were Apostles or not. In any case, the final element of decoration is in the spandrels above the squinch vaults, which show the ancient Christian images of shepherds flanked by sheep and stags.

The decoration of the baptistery negotiates, and in a most thoughtful way, several levels simultaneously — visionary, symbolic and didactic — while at the same time alluding to the ancient Christian past and reaching out to connect, both affectively and intellectually, to the Christian present. The visionary component is ensconced in the key positions of the apex of the dome and the vaults of the four squinches. These are the most arresting single elements of the decoration, pulsating with drama and light, yet at the same time, almost in inverse proportion to their visual assertiveness, the most distanced from the viewer's immediate comprehension and appreciation — the most arcane. The letters of the central medallion are a mechanism of extraordinary temporal complexity, figuring at once the person of Christ in the image of his name, the cross on which he died, the framework of eternity (alpha and omega), as well as the vision of Constantine *("in hoc signum...")*, thus intermingling effect and cause. The four beasts, which link an episode in the vision of Ezekiel (1:5ff.) to that of the Apocalypse (4:6ff.), had just recently begun to be interpreted by Christians as symbolic of the Evangelists. Christ's life transmitted to Christians through the Gospels thus envelopes the space, not in the fullness of its particularity but in the abstract essence of its truth.

Christ's life then serves as the basis for a didactic exposition in the main body of the dome in the various narrative scenes, through which the theme of the saving power of water flows. This is the dome as a teaching aid, a tool for

*Fig. 27. San Giovanni in Fonte, Samaritan Woman at the Well.*

the reinforcement of the lessons of the liturgy. The most diminutive figures are reserved for the spandrels, the figures of the shepherds, sheep and stags, which are also the most ancient in their pedigree. In the suggestive analysis of Katia Gandolfi, many of these elements, including the shepherds, sheep and stags, as well as the scenes of the Samaritan at the Well [Fig. 27], the *Traditio legis* [Fig. 25] and the Three Women at the Tomb are shown to have a resonance in the liturgy in a variety of its manifestations, in the *traditio psalmorum*, in the prayers of the consecration of the water, in the feasts that were considered preparatory to the sacrament of Baptism and in the rituals of the *traditiones* — *symboli, evangeliorum* and *patris*. Finally, the eight standing figures hold out the promise of the sacrament in the form of the crown of victory to all who partake therein.

The Neapolitan baptistery belongs to a group of monumental lavishly decorated baptisteries of late Antiquity, with ties to both the earlier and later examples, as Maier and others have observed. In its narrative loquaciousness, it most resembles the (albeit very fragmentary) baptistery at Dura Europos of the third century, which shares some of the same subjects, such as the Samaritan at the Well, the Walking on Water and the Women at the Tomb. In terms of medium and overall arrangement, there are resemblances between Naples and the Neonian baptistery at Ravenna of the mid-fifth century. The radial structure of the vault recalls the now lost decoration of the dome of Sta. Costanza in Rome, mid-fourth century, which, like the Naples baptistery, had a multitude of narrative subjects in the vault compartments. Indeed in late Antiquity, the decorative programs of tombs and baptisteries were often closely allied in subject matter.

Although stylistic differences have been perceived within the baptistery mosaics, there can hardly be any doubt that the entire project belonged to a single campaign and to a workshop indigenous to the city, not imported from somewhere else, such as Rome. The market for mosaics in Naples and its environs must have been, if not vast, at least sufficient to support an industry, given the amount of new Christian construction that occurred in the fifth century and given the contemporary taste for the medium. The number of mosaicked arcosolia and other surfaces in the Catacomb of San Gennaro (abundantly attested in the upper zone, not to mention in the Catacomb of San Gaudioso), is prodigious [see Figs. 16, 17], and there are telling resemblances between the figures here and in the baptistery. In the man or angel in the squinch vault of the baptistery (symbol of Matthew, Fig. 28) and the figure

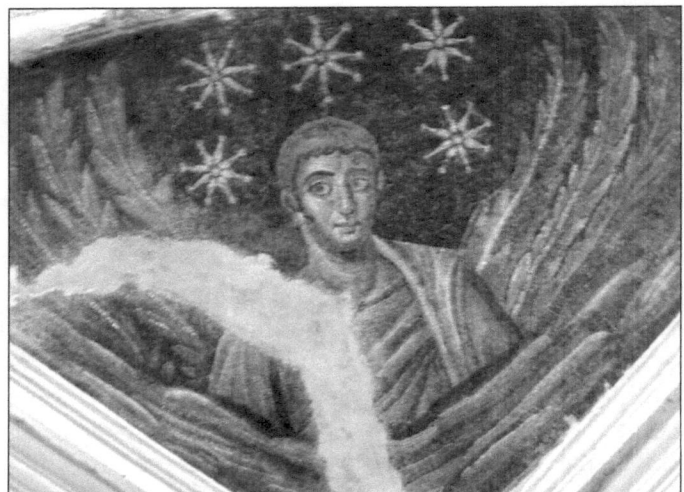

Fig. 28. San Giovanni in Fonte, St. Matthew.

believed by Fasola to be the oldest of the bishops in the "cripta dei vescovi," for example, there is a similar slurring of facial features and a criss-crossing of the torso by

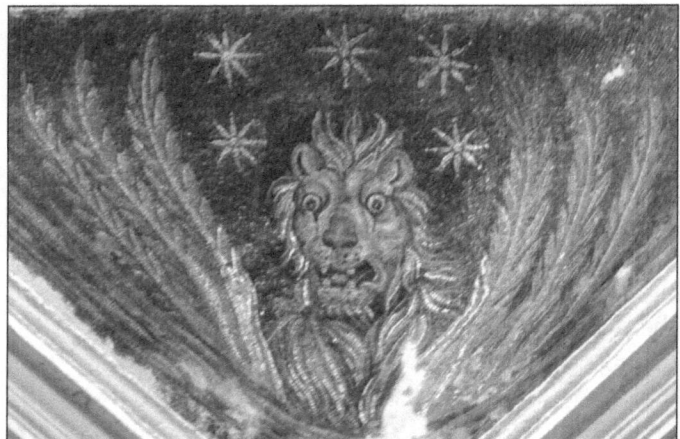

Fig. 29. San Giovanni in Fonte, the Lion.

ribbon-like highlights that have begun to detach from the modeling of the body. These figures are clearly not by the same hand, nor are they of the same date, but they belong to the same period, broadly defined, of the first half of the fifth century.

Yet the baptistery mosaics also at times transcend these comparanda, demonstrating a level of quality that is remarkable. The figure of the lion is a case in point [Fig. 29]. Brilliantly drafted and vividly colored, it recalls ancient traditions of expressive naturalism, which were much in evidence in the villas of the Bay of Naples. As is the case with the baptistery these were buildings in which an elaborate wall decoration (here in the form of painting) often took precedence over architecture in establishing an affective relationship with the viewer and thus played a transformative role. Surely this aspect of the decoration of the baptistery was important to the contemporary viewer, who must have experienced in it not only the familiarity but the pleasure of other spaces.

## *The Early Development of the Medieval City*

That a downward shift in population occurred in Naples in the early Middle Ages, with a decisive influence on the fortune of the city, is certain, although it is difficult to estimate the rate of change with any precision. There were watershed moments, such as the plague years of the sixth century and the invasions of the Goths and Lombards. Whitehouse raises the specter of a Naples c.700 that may have been "a predominantly agricultural community" in which a handful of institutions, including the administrations of duke and bishop and various churches and monasteries were dispersed (Whitehouse, in Hodges and Hobley, 31). But he also admits the possibility that Naples continued to retain

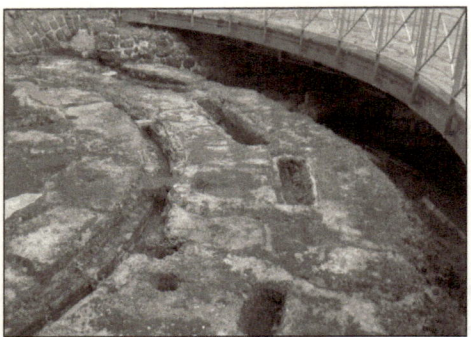

Fig. 30. Macellum at San Lorenzo Maggiore.

the city characteristics of a concentrated population with an economy of artisans and traders, as does Arthur (21–22).

Up to this point we have focused on a few exemplary cases that continued to form an important part of the topography of the medieval city. But there are a considerable number of others of which only traces remain. What must be reckoned with are the forces of destruction as well as the relentless rebuilding of older structures to meet

*See Interactive Map.*

Fig. 31. San Lorenzo Maggiore, early Christian basilica in archaeological context.

the needs of a changing present (Arthur, 59ff.). San Giorgio Maggiore (Fig. 2, lower decumanus/intersection of via del Duomo and Vicaria Vecchia), for example, founded by Bishop Severus (c.368–408/10), who also built the catacomb and cemeterial basilica and San Giovanni in Fonte, survives today essentially in the apse and ambulatory of the present church. Sta. Maria Maggiore (middle decumanus/via dei Tribunali), a foundation of Bishop Pomponius (514–32), is famous, not for the ecclesiastical edifice, of which little remains, but for the tower added to the church in the twelfth century, discussed below (pp. 44–46), as well as for the legend of its foundation, which occurred to exorcise a demon from the site. The plan of San Lorenzo Maggiore (middle decumanus/via dei Tribunali.), attributed to Bishop John II (533–55), built on the site of the ancient macellum [Figs. 9, 30], has been recovered [Fig. 31], in addition to its beautiful floor mosaics. San Giovanni Maggiore (via Mezzocannone), attributed to Bishop Vincent (555–78), survives in its early medieval incarnation also in the form of its apse, whose curving colonnaded wall, as at San Giorgio Maggiore [Fig. 2], also opens onto an ambulatory.

*See web gallery 100073.*

As we move through period of the duchy, however, these traces too begin to diminish, indicating a lessening of building activity, although numerous new establishments are attested in the sources. There is also the possibility that the reuse of ancient structures took a new direction. The insertion of a church dedicated to St. Paul into the magnificent Temple of the Dioscuri (middle decumanus/via dei Tribunali) is attributed to Duke Anthemius (801–16). The present-day church of

*See web gallery 100336.*

San Paolo Maggiore [Figs. 32a-b] stands majestically on the podium of this ancient temple, whose superstructure formed part of the church until it was damaged in an earthquake in the seventeenth century. Nonetheless a reasonable graph of building

*Fig. 32a–b. San Paolo Maggiore.*

activity in medieval Naples would have a trough in the middle, separating the high points of early (late antique and early medieval) and late (Angevin) phases of intense productivity.

■

One of the precious architectural and urbanistic remains of the medieval period is the twelfth-century tower of Sta. Maria Maggiore, the Pietrasanta, now freestanding in a small piazza on the via dei Tribunali [Cover, Figs. 33, 34]. The tower, which was once probably physically linked to the church through the intermediary structure of an atrium,

is built of brick, with an arched passageway at ground level whose axis lies parallel to the via dei Tribunali. This may have been the earliest of a series of medieval passage towers — straddling roads or walkways — that were typical of Campania and the South (San Lorenzo, Naples; Sorrento; Caserta Vecchia. See below, pp. 59–62). Its four walls and pyramidal top are pierced by single and double openings. In its lowermost zone the brick facades of the tower are enlivened with *spolia*, fragments of columns, entablatures and other miscellaneous pieces, which clearly served to demarcate different views. The most important facade of the tower [Fig. 34] faced the via dei Tribunali. Here the spoliate elements are arranged to form a more

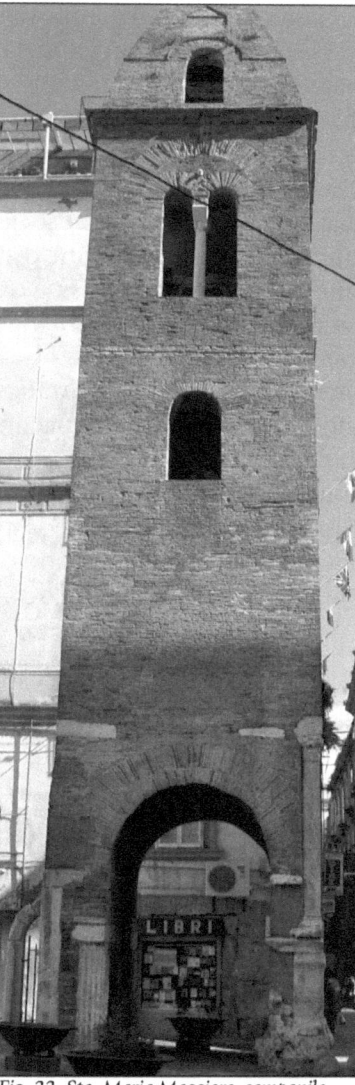

*See web gallery 100091.*

Fig. 33. Sta. Maria Maggiore, campanile (Pietrasanta).

or less symmetrical composition, with flanking columns on high bases framing a mélange of oblong elements of varying widths fitted together to form a horizontal socle-like register. On the other side of the tower, the spoliate elements are much reduced and simplified: the uprights at the corners are no longer columns but crude rectangular slabs and the horizontal socle-like arrangement has disappeared. Clearly here the distinction was between front and back, between the side of the tower that functioned as a public presentation of the edifice (facing the decumanus) and the side that did not. On the inner walls of the arched passageway, the arrangement forms an intermediate solution, with uprights and socle like the front, but executed in less finished materials. Such distinctions are interesting to observe, indicating as they do a poignant disparity between ends (aesthetic rationalization) and means (the mismatched and beaten pieces of marble that were accessible to the builders of the edifice).

■

Fig. 34. Pietrasanta, south elevation.

Fig. 35. Sta. Chiara, cloister gallery.

# CHAPTER 2: NAPLES IN THE HIGH & LATE MIDDLE AGES
by Caroline Bruzelius

*Religious Foundations and Urban Topography*
The grid plan of the ancient Greco-Roman city deeply influenced the topography of medieval Naples. The lower decumanus, now known as via S. Biagio dei Librai, or "Spaccanapoli," along with the parallel upper decumanus (now via dei Tribunali), remained the major east-west axes of the old town. Churches and monasteries founded in the early Christian period were inserted into the densely inhabited and compact heart of the city, often replacing ancient temples, markets and houses, fragments of which can be seen in the excavations under the cathedral (duomo) and the cloister of San Lorenzo Maggiore [Fig. 31]. For the most part the long narrow blocks of the ancient city conditioned the orientation of the medieval churches, which tended as a result to be aligned north-south. It was also normal practice to reutilize Greek and Roman materials *(spolia)*, especially columns, bases and capitals, which were later integrated (yet again) in the reconstructions of these churches in the twelfth and thirteenth centuries.

*See Interactive Map.*

The past thus had a weighty valence in Naples: the ancient grid determined the orientation of the churches and re-used building materials evoked the ghosts of long-lost monuments of Antiquity. Both were to condition what would be built centuries — even a millennium — later. Medieval Naples was in dialogue with its ancient past long before the early-modern period made this an explicit artistic and intellectual endeavor in the humanist court of the Aragonese kings.

The insertion of Christian churches and monasteries into the center of the city was probably facilitated by the decline in population that took place everywhere in the late ancient world. In Naples, the process of depopulation may have been accelerated by natural disasters, such as plagues (as a port city Naples was always particularly susceptible), earthquakes, volcanic eruptions and the "mud slide" that covered the ancient Roman market at San Lorenzo in the late fifth century C.E.

Nevertheless, the construction of churches within the city was probably a complicated and costly process because the narrow north–south blocks of the Greek city plan imposed constraints on the new religious foundations. As a result these were built with their apses in the north and portals to the south (as at the old cathedral of Sta. Restituta). The constraints of the ancient city plan were to remain a central feature of church architecture in Naples through most of its history, although in the late thirteenth century the eastern extension of San Lorenzo (begun in the 1270s) and the reconstruction of the cathedral (begun 1294), interrupted several narrow north–south streets (the *vicoli*; or the *cardines* or *stenopoi* of antiquity) [Fig. 36].

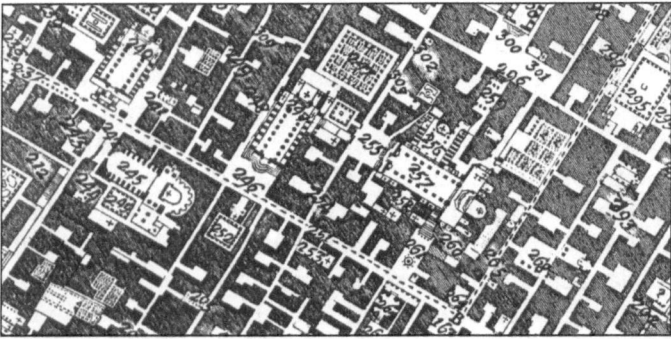

Fig. 36. Detail of Duca di Noia plan: San Lorenzo (245) and cathedral (255–257).

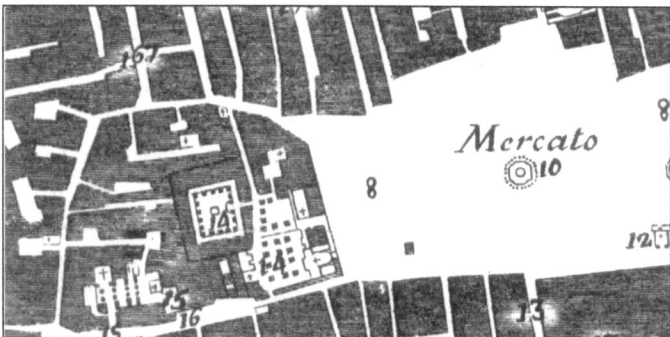

Fig. 37. Detail of Duca di Noia plan: San Giovanni a Mare (15) and Sant'Eligio (14).

On the other hand, churches outside the city walls, such as the hospital churches of San Giovanni a Mare and Sant'Eligio al Mercato, were oriented with their altars in the east [Fig. 37]. These two foundations, both adjacent to the harbor and the new central market established by Charles of Anjou in the 1270s (the Campo Moricino), are among the few surviving testaments to the active culture of secular piety in the form of confraternities and associations dedicated to good works. Not surprisingly, most hospitals and hospices were located on the cheaper land outside the city walls and near the port.

Monasteries, convents (mostly Benedictine and Basilian), as well as various other types of pious foundations came to occupy a large proportion of urban space in Naples and played a fundamental role in its protection and governance from the ninth century up to the Norman conquest in 1139. With Norman domination (1140–90), these were pushed into a secondary position behind the regional seats of civic administration *(seggi)* and later the foundations of the mendicant orders, but the old monasteries nevertheless continued to be powerful vehicles for the cultural, social, economic and spiritual life of the city.

Outside the ancient center some new religious foundations were designed to take advantage of the major arteries into the city, such as the great double convent, Sta. Chiara, founded in 1310. The entrance to the church faces the lower decumanus and marks the entrance to the city from the west, on the side of the city closer to the new aristocratic zone of noble palaces and Castel Nuovo developed by Charles I of Anjou (1266–85) and his successors [Fig. 38]. At Sta. Chiara, the desire to position the entrance on a primary thoroughfare caused the presbytery to be located in the south and the entrance to the north. The importance of Sta. Chiara's vast conventual complex is marked by a monumental tower with four large-scale Gothic inscriptions (1340) commemorating the foundation and dedication of the church.*

\* See Documentary History, chap. 6, reading 1.338 and web gallery 1001.53.

When we think of the material remains of medieval Naples, however, we must recognize that very little remains of the monuments of the city, and almost nothing from the centuries prior to 1250. Most of the medieval churches were transformed by Renaissance and baroque redecoration; indeed, until the bombardment of World War II and subsequent restoration campaigns, few would have been visible under their later revetments of baroque stucco and marble. A number of important medieval churches are still concealed under lavish baroque decoration (Sta. Maria del Carmine, Sta. Maria la Nova and Sant'Agostino alla Zecca). Perhaps the most striking churches of Naples, such as Sta. Maria Donnaregina and San Lorenzo, were radically restored by Bruno Chierici in the first decades of the twentieth century. Most restorations, and especially those after the Allied bombardments of 1943, returned the buildings to an interpretation of the original medieval structure rather than attempt

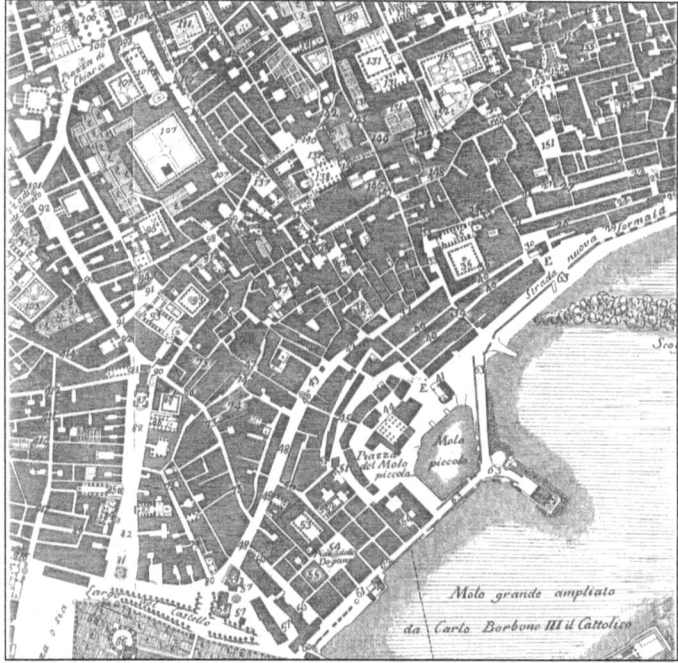

*Fig. 38. Detail of Duca di Noia plan: Castel Nuovo (66) and Sta. Chiara (107).*

to reconstruct the sumptuous baroque decoration (Sant'Eligio, San Giovanni a Carbonara and Sta. Chiara, among others). An even greater loss to the medieval fabric of the city, however, occurred during the *Risanamento* (urban renewal) of the late nineteenth century, which demolished churches, monasteries and cloisters in order to create a system of monumental avenues, undertaken after a severe cholera epidemic in 1884. (See Santore, 209–11, 214–17.)

Many other churches had already been destroyed or heavily rebuilt after earthquakes in the late Middle Ages and early-modern period, especially those of 1349 and

Figs. 39. Palazzo Penna (above).
Fig. 40. Palace of Philip of Taranto (right).

1456 (for example, San Domenico and San Pietro Martire). In addition, the wars between the Angevins and the Aragonese damaged or destroyed religious foundations located near the Arsenal and Castel Nuovo, such as Queen Sancia's convent of Sta. Croce di Palazzo, in the area that is now the Piazza del Plebiscito, and the complex of Sta. Maria Incoronata,

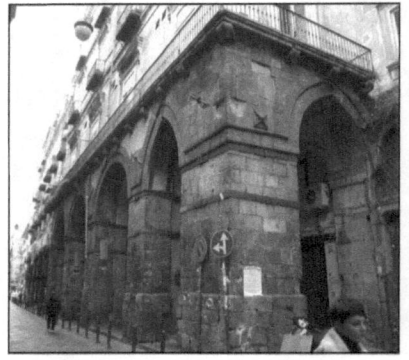

on via Medina. Even more extreme has been the near total destruction of noble villas, palaces and extensive gardens of the medieval court, none of which survive intact, with the exception of the facade of Palazzo Penna and the remains of the palace of prince of Taranto on via dei Tribunali [Figs. 39, 40]. These are small fragments of what must have been a splendid display of the secular architecture of princely and noble palaces. The same can be said of civic buildings: not one of the famous *seggi* (the seats of local government) survives intact.

There are thus few testaments to the richness of the physical fabric of the medieval city. Some sense of its splendor,

however, can seen in the *Tavola Strozzi*, a panel now in the San Martino Museum that represents Naples in the late fifteenth century [Appendices, pp. 126-27 below]. For the most part, the churches that emerge on the city's skyline are those built during Angevin rule: Sta. Chiara, San Domenico, San Lorenzo, the cathedral, San Giovanni a Carbonara and Sant'Agostino.

The surviving medieval churches of Naples, which date for the most part to the late thirteenth century and after, have two important characteristics: they reflect the persistence of strong local Campanian traditions in architecture and its decoration and yet at the same time an openness to foreign influences and imported structural concepts. Although the literature has traditionally associated the external elements with ideas and builders imported by the northern conquerors and commissioned by royal patrons: the Normans, Swabians and Angevins (such as the ambulatory, rib vaults and bar tracery windows of San Lorenzo), recent scholarship now suggests that merchant communities, as well as the mendicant orders, were also important forces in the foundation of religious communities and the introduction of new spatial and architectural ideas into the Kingdom of Sicily in general and Naples in particular. We can probably also assume that, as a port city, Naples (like Salerno, Gaeta and Amalfi) was deeply influenced by both Byzantine and Islamic culture, but no evidence of this now survives, nor are there more than fragmentary attestations of Lombard art.

The only extant twelfth-century church, San Giovanni a Mare, attests to a blending of old and new, of local and imported ideas. The foundation belonged to the international order of the Knights Hospitaller, but there is no documentation of the foundation of

*See web gallery 100099.*

the church and hospital. The first evidence of the community is a financial bequest in a document of 1186. It is likely that by this time the church had been erected, though the absence of surviving comparative monuments and the character of the building render a precise dating difficult. The nave consists of five bays of groin vaults supported by columns, terminating in a wide transept [Fig. 41]. The original semi-circular apse was replaced c.1300 by a second transept and by three rectangular eastern chapels. The nave arcade is supported by handsome re-used columns and capitals, and fragments of a Roman architrave also frame the original chancel arch at its termination. The groin vaults of the nave are unusual in combination with columns, although this type of covering exists in Campanian crypts, where the small dimensions of the interior spaces make such an arrangement stable. The irregularity of the rectangular eastern chapels is the result of constraints on the site by buildings to the east. A transverse hall, adjacent to the east wall of the presbytery (reconstructed in the late fifteenth or sixteenth century and now a textile wholesale store) may once have been part of the twelfth-century hospital. The earthquake of 1456 damaged the church, and the subsequent addition of lateral chapels along the nave and a heavy layer of plaster and whitewash render a detailed study of this building almost impossible. Analogies can be made, however, with the nave and aisles of the cathedrals of Carinola or Sessa Aurunca, both in Campania and partially dating to the early twelfth century.

The hospitals of Sant'Eligio and San Giovanni a Mare attest not only to charitable institutions but also to the communities of foreign travelers, merchants and religious groups who settled in or passed through the

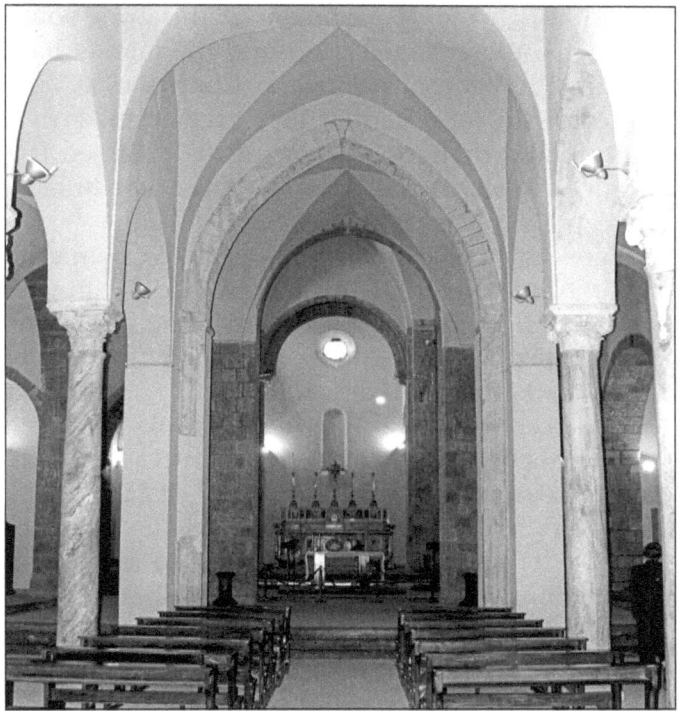

*Fig. 41. San Giovanni a Mare, view of the nave.*

commercial areas outside the walls and near the port. We can imagine communities of foreign merchants living and working in this part of the city, in addition to parishes and other pious foundations that served their needs. Recent excavations in preparation for the new *Metropolitana* transit system of Naples and the archival research of Giovanni Vitolo and his doctoral students at the University of Naples are expanding our understanding of this area, part of which was known as the Campo Moricino (now Piazza del Mercato, Fig.

37). Although the development of this zone south of the city, the enlarged walls and the market have traditionally been attributed to Charles of Anjou, new evidence suggests that they predate his arrival in 1266, and that at least part of the enlarged fortifications towards the port had been constructed between 1258 and 1263.

There are strong indications of an economic revival of Naples in the twelfth century, and the growth, prestige and expansion of the city were given special impetus by the foundation of the University of Naples by Emperor Frederick II in 1224.\* Until this date, the centers of learning in Campania had been the Benedictine monasteries of Montecassino and Cava de' Tirreni, the cathedral school of Capua, and the medical school at Salerno. The new university of Naples now provided training in law to subjects of the kingdom.

\* *See Documentary History, chap. 5, reading 1224.*

It was perhaps the need to establish schools of theology as a counterpart to the new secular university that prompted Archbishop Peter of Sorrento (1217–46) to assist the Dominicans and Franciscans in settling in central Naples. The Dominicans were invited in the early 1230s to occupy the hospital at Sant'Angelo a Morfisa on the west side of the city, and in 1234, the same year that the University of Naples was re-opened, the archbishop supported the founding of a Franciscan convent at the old basilica of San Lorenzo in the heart of the city. This was the second Franciscan establishment in Naples, as the first had been established outside the city on a site that was in 1279 to become Castel Nuovo. In bringing the mendicant preaching orders to the core of the city, the

archbishop perhaps wished to develop effective countermeasures to the spread of the heresies that were typical of the rapidly growing population in medieval cities. The Dominican and Franciscan convents of the center soon became the principal schools of theology in southern Italy, and in this way the university was flanked by Dominican and Franciscan institutions that were to flourish and take their places among the great centers of learning of medieval and Renaissance Europe.

Archbishop Peter of Sorrento presided over an ancient and venerable episcopal complex. The old cathedral, by this time dedicated to Sta. Restituta, was embedded in a series of courtyards, baptisteries, chapels and hospitals. The basilica and its atrium were located above the major decumanus (via dei Tribunali) that led through the city, past the Castel Capuano, and on to the road north connecting Naples to the via Appia at Capua on the northwestern edge of that city. The steep descent of the site from the foundations of Naples' cathedral meant that it was accessible from the street by a long flight of steps, still visible on the Piazza Riario Sforza on the south side of the cathedral. In antiquity and for most of the Middle Ages this piazza had an ancient bronze horse, perhaps part of an equestrian statue (possibly of Constantine, considered the patron of Sta. Restituta). In 1322, however, it was melted down to make bells for the newly rebuilt cathedral.

*See web gallery 100059.*

*See web gallery 100255.*

The episcopal complex consisted of many ancient buildings, some parts of which were associated with the Apostle Peter's legendary conversion of the Neapolitans, while the first basilica was traditionally attributed to

Fig. 42. Naples Cathedral, the vault of the tower of 1233.

Constantine. There was also an atrium with ancient columns, halls for the clergy, a baptistery (still intact*) and various halls and courtyards for the public and the clergy. In 1233 Archbishop Peter of Sorrento embellished the complex with the addition of a free-standing tower at the northeastern corner of the atrium above the Piazza Riario Sforza. Only a fragment, the interior vault [Fig. 42], survives of this structure; the rest collapsed in the earthquake of 1456 and was partially rebuilt by Archbishop Cardinal Piscicello. The coffered vault is a striking testament to the revival of classical taste in thirteenth-century Campania. It also testifies to the use of architectural concepts derived from antiquity (the coffering) combined with the structural advantages of the pointed arch.

This lost tower was copied in 1234 by Bishop Andrea of Capua at Caserta Vecchia [Fig. 43], which also passes over a road and is covered by a vault with shallow coffering. Here an inscription attributes the tower to Bishop Andrea and gives the date of 1234. Both are road-straddling towers frequently found in Campania,

*See above, 24–41.

as at Sta. Maria Maggiore or the Pietrasanta, and all integrate *spolia* elements into their design. A similar tower can be found at the cathedral of Sorrento.

*See web gallery 100091.*

These episcopal towers reflect the new classical spirit that dominated the architecture of Campania in the 1230s, a taste also visible in the portico of Sessa Aurunca [Fig. 44], or the reconstructed transept and crossing piers at Caserta Vecchia. These monuments attest to a rich

*Fig. 43. Caserta Vecchia, the tower of 1234.*

culture of classical renewal and stylistic innovation in the cathedral hierarchies of thirteenth-century Campania. The roots of this phenomenon may lie in the classicizing tastes that radiated from Montecassino starting in the late eleventh century, artistic taste that seems to have become an important part of the intellectual culture propagated in the cathedral school of Capua, where many of the prelates mentioned here were trained. The classicism reflected in these episcopal monuments corresponds to the well-known taste for the antique in the art of Frederick II, most notably the Arch of Capua, also of the 1230s, and the classicizing taste of the episcopal projects suggests that an interest in antiquity was not the sole purview of the emperor but more broadly characteristic of the elite cultures of Campania from c.1220 through c.1250. Certainly the refined and erudite inscriptions of the two cathedral towers suggest a distinguished tradition of Latin learning and a high level of both visual and literary culture.

## *The Patronage of Pious Confraternities, the Angevins and the Churches of the Friars*

The founding of a university, which meant the creation of an intellectual and administrative elite and the existence of thriving merchant communities, helped expand Naples into an important commercial, religious and intellectual center in the twelfth and thirteenth centuries. In the process the city began to eclipse the older traditional centers of trade on the west coast of Italy, such as Amalfi and Salerno. Naples and nearby Pozzuoli were closer to the via Latina and the via Appia, which led towards Rome and Tuscany, both major centers of Angevin support. The growing emphasis on political and mercantile relations with the north,

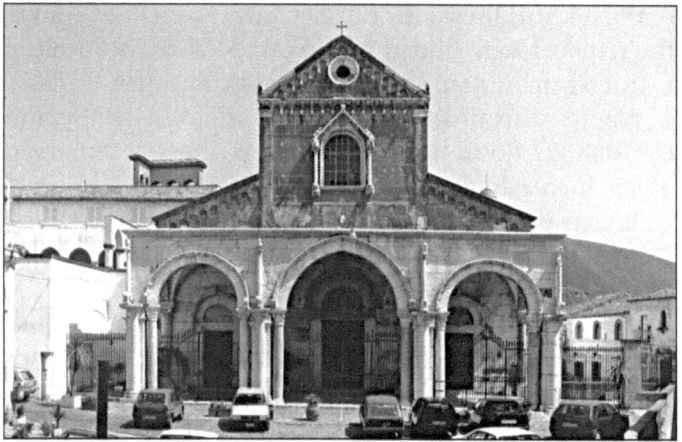

Fig. 44. Sessa Aurunca, west porch of the cathedral.

especially the papacy and the kingdom of France, shifted the balance of power away from the old Norman capital of Palermo as well, which in any event had been lost with the revolt of 1282. Indeed, by the early thirteenth century Palermo had begun a long decline: Frederick II spent almost no time there after his childhood, and his Angevin successors paid long propagandistic attention but only passing energies to reconquering Sicily. Charles of Anjou's plans to conquer the eastern Mediterranean in the first decades of his reign meant that he spent most of his time, resources and energies repairing or establishing castles and fortifications along the coast of Apulia. He also restored fortifications inland in Basilicata at Melfi and Lagopesole, for example, and in the late 1270s turned his attention to Naples as a city with better access to Rome and the north. Nevertheless, certain traditions remained stoutly attached to Palermo and its region: for example, when (after the failed crusade to Tunis in 1270), Charles of Anjou obtained part

of the body of his saintly brother, King Louis IX of France, the remains were buried in the cathedral of Monreale, a major Norman royal shrine just outside Palermo.

Naples thus provided access by sea to Marseille and by road to Rome and Tuscany. As the city emerged as an increasingly important political and economic center in the 1270s, several large-scale urban projects changed its character. The old royal residence of Castel Capuano on the eastern side of the city, built by the Normans and expanded by Frederick II, was considered vulnerable to attack from land and insalubrious, so in 1279 Charles of Anjou initiated the construction of a new castle, Castel Nuovo [Fig. 77] on the opposite (southwestern) side of the city. This site was cooled by sea breezes. It also provided greater protection from attack as well as greater ease of escape, should the need arise, a consideration that might have emerged as a result of the numerous revolts in the kingdom after 1268. The new palace, on a site that had been settled by Franciscans in c.1217, was erected in about three years, though Charles's successors continued to make additions and improvements in the following decades. As a result of the increasing importance of Naples as the administrative center of the kingdom, Castel Nuovo became the primary royal residence, a role that increased after the outbreak of the War of the Vespers, the revolt of the island of Sicily in 1282,* when Naples became the center of royal authority, administration and power. With the exception of the royal chapel of Sta. Barbara (to which we return below, pp. 94, 103) and some portions of wall, however, the structure of Castel Nuovo was almost entirely rebuilt by Alfonso of Aragon in the fifteenth century.

*See web gallery 100044.*

* See Documenta History, chap. 6, reading 12

A number of buildings and public works in Naples have been attributed to Charles of Anjou, but the evidence available tends to reconfigure and reduce his role in substantial ways. Charles I was not an active patron of religious architecture (the traditional attributions of the cathedral and San Lorenzo to him should be dismissed), nor did he undertake the important urban projects of moving the market to the Campo Moricino and refortifying the city on its southern flank towards the port, which are now dated to before the French invasion. In 1270, however, the king donated parcels of land to two pious foundations, the confraternity of Sant'Eligio ("al Mercato") and the Carmelite friars (Sta. Maria del Carmine) on either side of the market, perhaps in an effort to "sanitize" this part of the city where in 1268 Conradin, the young Hohenstaufen pretender to the throne, had been decapitated.*

*See Interactive Map.*

On the west side of the market, the confraternity of Sant'Eligio dedicated a church and hospital to three French saints: Martin, Eloi and Denis. Although historiography has perpetuated the tradition that the French founders were noble, Giovanni Vitolo has recently demonstrated that they were members of a consortium of merchants who, with the support of the Burgundian Archbishop Aiglerius (1266–85), established the hospital to provide for the care and burial for French and Provençal immigrants and soldiers without family. It is probably no coincidence that this foundation, now known simply as Sant'Eligio, was established on the side of the piazza near the older hospital and church of San Giovanni a Mare, with which it shares certain similarities in plan.

* See *Documentary History*, chap. 6, reading 1268.

These three foundations near or beside the market — the older San Giovanni a Mare and the new

establishments of Sta. Maria del Carmine and Sant'Eligio — were to become important centers of Neapolitan piety. Sant'Eligio had a long and distinguished history as a hospital through the Aragonese period and beyond, and at Sta. Maria del Carmine the church and its miraculous icon of the Virgin are still among the most venerated sites in Naples. San Giovanni a Mare long thrived as a hospital and center of pious confraternities. Their success was no doubt related to their location in the popular, prosperous and bustling commercial center of the market and the port.

In the donation documents, Charles I stipulated that the terrain given to Sant'Eligio and Sta. Maria del Carmine was to honor his parents, Louis VIII of France and Blanche of Castile, and for the everlasting salvation of his soul. The church was completed after 1301 with donations from King Charles II (1268–1309). Nothing visible remains of the medieval structure of the Carmine apart from the rib vaults of the presbytery and portions of the conventual buildings, covered by layers of stucco. The Simancas Archive in Spain, however, preserves a plan of 1662 [Fig. 45]: a wide nave flanked by rows of lateral chapels, a narrow transept and a polygonal apse.

The design of the Carmelite church is typical of the large-scale buildings of the mendicant orders. Rows of chapels flank a nave without aisles. The plan is similar to that of Sta. Maria la Nova, the Franciscan church erected after 1279, when the original settlement was taken over for the construction of Castel Nuovo, and to that of the later foundation of Sta. Chiara, begun in 1310. Wide naves flanked by chapels were especially common in Naples after 1280 and may reflect the ever-growing importance of private donors who financed

*See web gallery 100232.*

the construction of mendicant churches with family burial chapels where wealthy Neapolitans could bury, and pray for, their dead. Lay burial in mendicant churches became one of the most important sources of income for the new orders, which had espoused a commitment to apostolic poverty. Unlike the older religious orders (the Benedictines and Cistercians, for example), the friars were not endowed with land and rents that could support the religious community. As we shall see below, similar types of chapels were incorporated into the design of the new cathedral and added to the old basilica of San Lorenzo.

Sant'Eligio is the most "purely French" architectural structure of thirteenth-century Naples. The church was probably begun soon after Charles I's donation of land in 1270, because the battered capitals and architectural details of the nave interior, as well as the portal on the

*See web gallery 100069.*

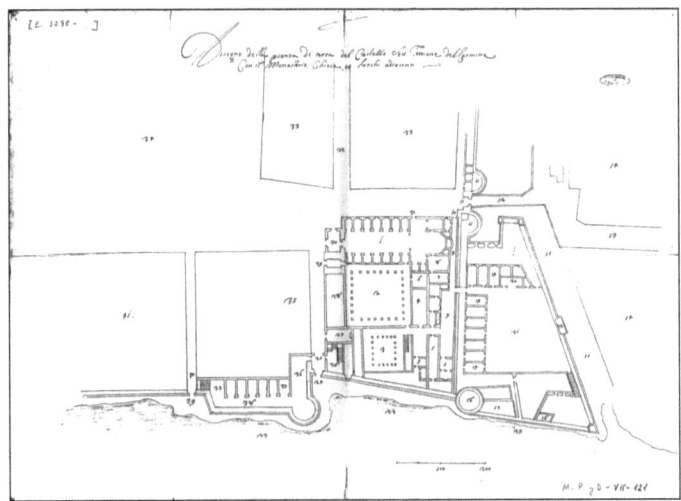

*Fig. 45. Sta. Maria del Carmine, plan (Archivio di Simancas).*

south flank, closely resemble French models of the 1260s and 1270s. However, the building was modified many times while construction was underway: the rib vaults planned for the nave were never installed, the westernmost bay increased the dimensions of those to the east, and the first apse was replaced by a transept and new presbytery initiated in 1279 after a second donation of land by King Charles [Fig. 46]. Excavations undertaken after World War II revealed the original apse, but no records of this discovery remain. The wider bay at the west antedates the reconstruction of the east end, however, because it was also planned for rib-vaults, whereas the new transept was not intended to be vaulted [Fig. 47]. The high uninterrupted volume of the transept can be related to structures of the 1290s, such as the cathedral of Naples, begun in 1294. This, in combination with other architectural details, suggests that reconstruction of the eastern part of the hospital church was interrupted by the War of the Sicilian Vespers in 1282.

But this is not the end of the anomalies at Sant'Eligio: after the earthquake of 1349, the closely spaced compound piers, designed to support the slender ribs of a vault,

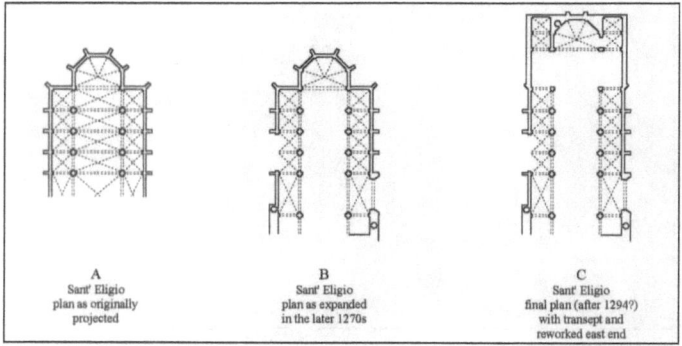

Fig. 46. *Sant'Eligio al Mercato, hypothetical reconstruction of construction phases.*

were replaced by large and more broadly spaced piers of grey piperno, a harder form of tufa more resistant to weight and stress than the yellow tufa of the original building. The shape of the new piers recalls the polygonal supporting elements that can be found in the mid-fourteenth century monuments in southern and central France, such as La Chaise Dieu in the Auvergne.

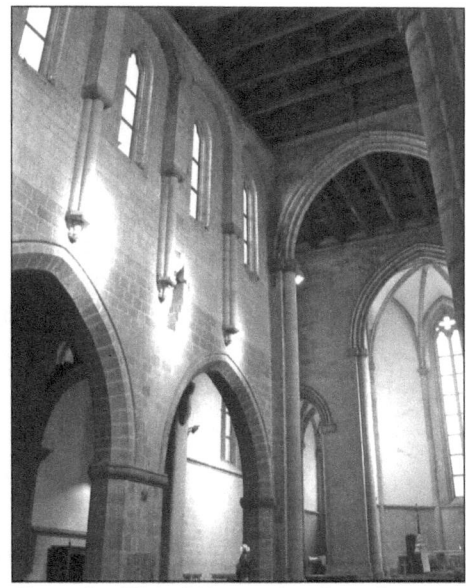

Fig. 47. Sant'Eligio al Mercato, view of nave & transept.

The west façade of Sant'Eligio (to the extent that it was ever completed) is now encased in apartment buildings and no longer visible. The portal on the south flank of the church, recently cleaned and restored, is, however, a testament to the presence of high-quality French workmanship in the city [Fig. 48]. The lush and richly sculpted crockets, and the elegance of execution in moldings and bases, are splendid examples of the current French Rayonnant style of the Île-de-France. Recent cleaning of the portal has revealed a novel feature, moreover: there is a band of white limestone between the darker piperno moldings of the innermost and outermost archivolts, a coloristic element not found in France.

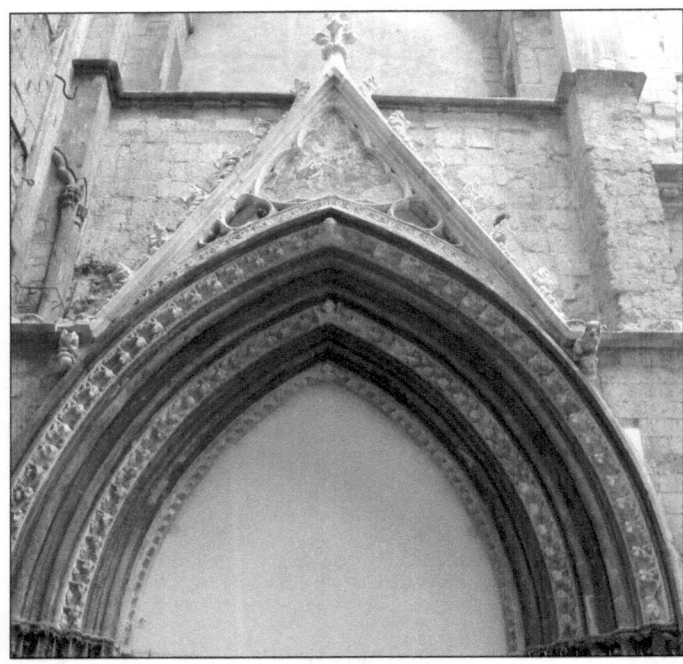

Fig. 48. Sant'Eligio al Mercato, west portal.

*See web gallery 100232.*

Sta. Maria la Nova, the first Franciscan community of Naples, has been entirely rebuilt, and nothing medieval remains. The importance of this convent, lavishly patronized by the Aragonese in particular, is attested by the dimensions of its two large cloisters and the scale of the claustral buildings [Fig. 49, no. 93]. Nevertheless, and from early in its history, this Franciscan community seems to have been associated with the more rigorous branch of the order.

*See web gallery 100073.*

By far the most prominent Franciscan establishment in thirteenth-century Naples, however, is San Lorenzo Maggiore, founded in the city center in 1234. The plan of the early Christian basilica, placed over the Roman

macellum [Fig. 31], was rediscovered in the post-war restoration and excavation of the site. This original structure was adapted for the use of the Franciscans in several successive phases and later replaced by the church that is on the site today [Fig. 50]. Evidence that San Lorenzo was already flourishing by the 1240s is suggested by the presence of important members of the Franciscan Order, such as John of Parma, later minister general, who were teaching in the *studium*, and the community of friars and students seems to have grown very rapidly. Fragments of the medieval cloister and refectory attest to the large number of friars.

San Lorenzo is one of the best known and most loved churches of Naples: Boccaccio first saw Fiammetta there, and Petrarch was staying in the friary during the devastating storm and tidal wave of 1343. Its location beside the city's tribunal and its close association with some of the important administrative centers, the *seggio* di Montagna and the Tribunale, endowed the complex with a particularly prominent political role over the

*Fig. 49. Detail of Duca di Noia plan: Sta. Maria la Nova (93)*

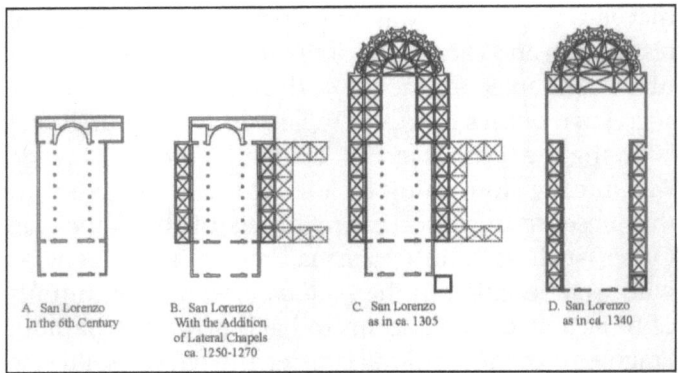

Fig. 50. San Lorenzo, hypothetical reconstruction of construction phases.

course of Neapolitan history. Later, during the turbulent years of the sixteenth century, San Lorenzo was closely associated with several revolts and some of the most dramatic moments of Neapolitan history in which the friars played a prominent part.

Recent scholarship suggests that the Gothic choir was probably begun in the 1270s as an enlargement of the earlier church, but the new extended east end may have been preceded by the addition of side chapels to the nave [Fig. 50B and C]. As we shall see below, the sixth-century nave was demolished only after 1324 to make space for the vast new structure we now see [Fig. 51]. Only one document pertains to construction at the church prior to the 1290s: the commutation in 1284 of part of a fine against the Rufolo family of Ravello in favor of the "repair" and "renewal" of the church. It seems likely that the document refers to the new east end, and the amount of the fine, 400 *once*, would have made a significant impact on the project. Nevertheless, it seems as though the Gothic apse and

adjoining bays were not actually completed until c.1300 with donations from Charles II.

Scholarship has traditionally considered the Gothic extension of San Lorenzo as an example of the architectural expertise brought to Italy by the French conquerors. But recent research suggests a different scenario: that the Gothic parts of San Lorenzo were designed by Franciscan builders, which explains the archaic quality of many architectural details, such as the similarities between the piers at San Lorenzo in Naples and similar supports around the hemicycle

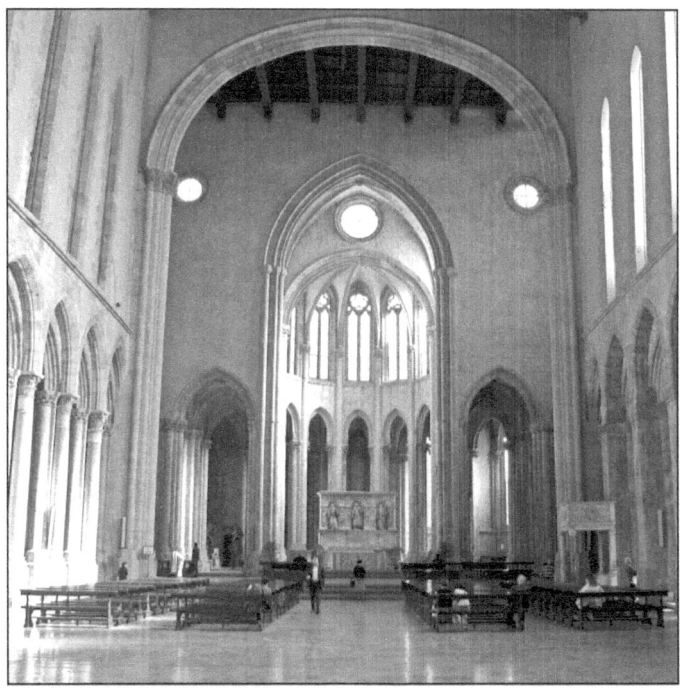

*Fig. 51. San Lorenzo, view of the nave toward the chevet.*

of San Francesco in Bologna. The seductive aura of "Frenchness" at San Lorenzo is belied by the handling of its constituent parts, and indeed there is little here that reflects contemporary French models, unlike the much smaller church of Sant'Eligio al Mercato, discussed above.

The design of the new choir was intended to extend and practically double the church in length [Fig 50C]. Foundations underneath the pavement indicate that the early Christian church, like that of the Parisian Franciscans, had no transept in the original design. The alignment of the old nave columns would have been continued towards the east by a series of compound piers that supported a wooden truss ceiling over the main volume, but there were pointed rib vaults in the aisles that still survive in the ambulatory, radiating chapels and the chancel.

Construction in the heart of the ancient city must have been a costly affair, as the property all around San Lorenzo was owned either by other monasteries (especially the much older convent of San Gregorio Armeno) or by private individuals. The extension of the church and monastic complex entailed the expensive acquisition of land and often litigation with neighbors.

As noted above, the *seggio* di Montagna, the local administrative group of the urban patriciate, was closely linked with the financial affairs of San Lorenzo. As Rosalba Di Meglio has recently demonstrated (2003), members of the *seggio* managed the finances of the friars, who as Franciscans were not allowed to have direct contact with money. It would appear as well that members of the *seggio* collectively and individually supported the expansions of the church. Indeed, the lateral chapels were soon "colonized" by noble families, who acquired

them as family chapels and burial places, and the floor was also paved with the tombs of patrons. By the end of the thirteenth century, the royal family was also deeply involved in San Lorenzo, as is evident from the fragmentary series of imposing royal tombs erected in the area of the transept.

The war of 1282 probably delayed or interrupted the completion of the eastern extension, as was the case with construction projects elsewhere in the kingdom. It was finished with donations from Charles II of Anjou for its "perfection." In its present highly restored state, we cannot be certain which parts were left incomplete, but frescos in the south transept arm, dated to the first years of the fourteenth century, would suggest that by c.1305 the extended church was finished and in operation. In 1305 and in 1310, two members of the royal family, a son, Raymond Berengar, and a grandson of Charles II, Louis, were buried in the area of the south transept.

In his monumental study of 1969, Ferdinando Bologna identified the master of the frescos in the south transept as Montano d'Arezzo, a painter documented as in the service of the Angevin court in the first decade of the fourteenth century. Although fragmentary, the scenes of the Nativity and the Dormition of the Virgin [Figs. 52 and 53] are among the earliest evidence of major artists from central Italy and especially Tuscany employed in the prestigious commissions of the Neapolitan court. Montano d'Arezzo also worked for the duke of Taranto, and he executed the large image of the Virgin at the sanctuary of Montevergine. Bologna has proposed that he decorated part of the Minutolo Chapel in the cathedral as well.

*See web gallery 100073.*

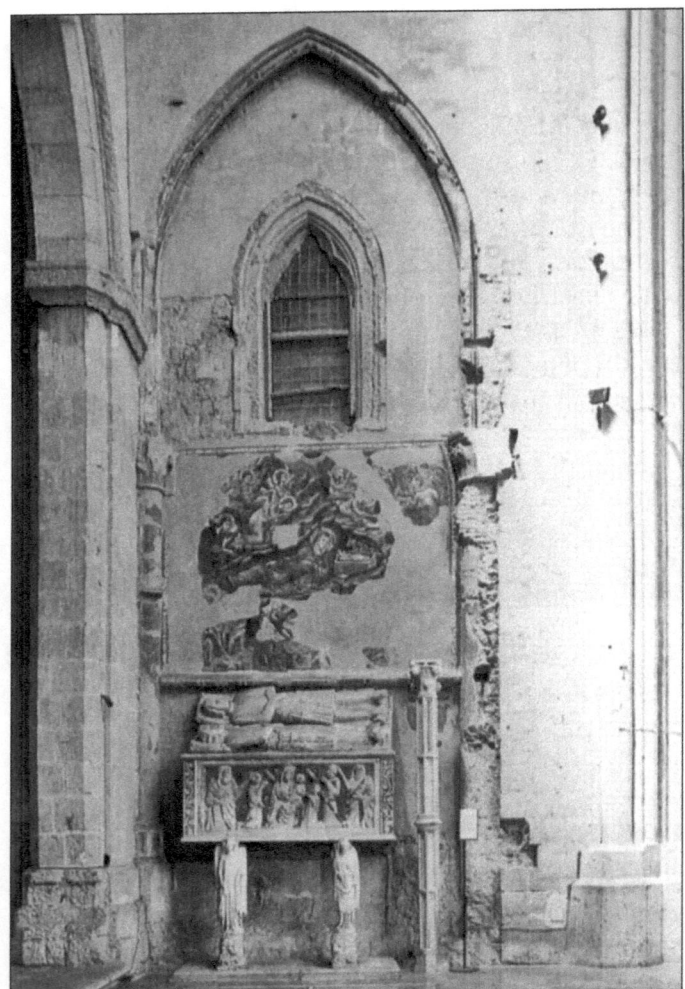

Fig. 52. *San Lorenzo, west wall of south transept with fragments of Nativity fresco.*

The final phase of reconstruction at San Lorenzo, which involved its extension to the west and a new facade, was perhaps stimulated by the need for additional burial chapels

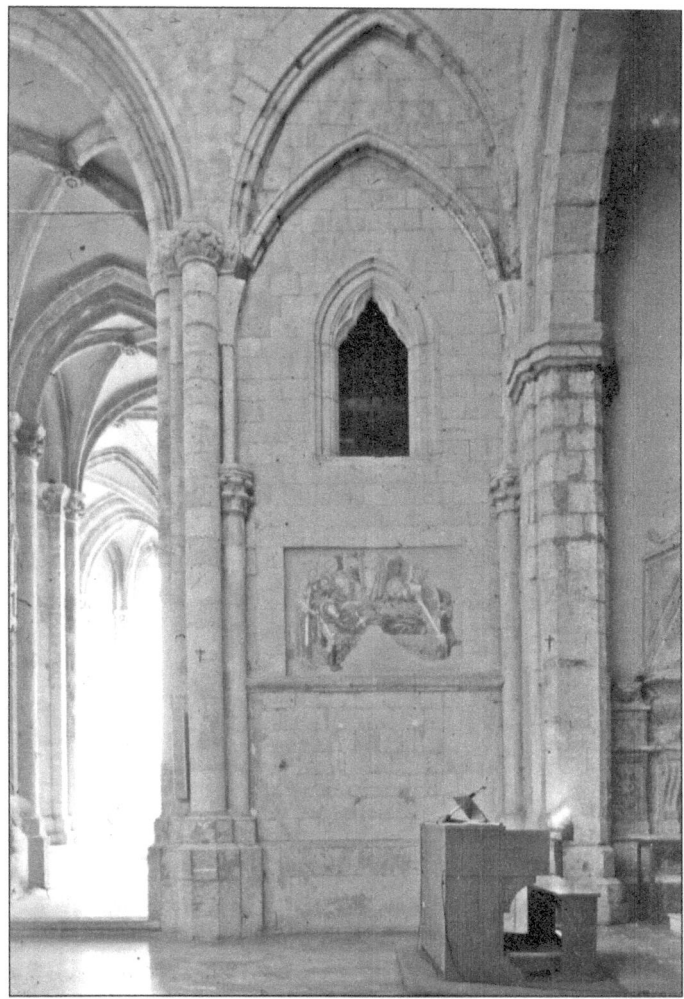

*Fig. 53. San Lorenzo, east wall of south transept with fragments of Dormition fresco.*

[Fig. 50D]. At her death in 1323, Catherine of Austria, the first wife of Charles of Calabria, heir to the throne, left a

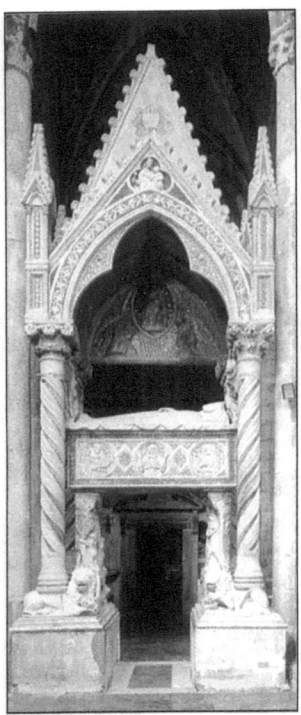

Fig. 54. San Lorenzo, tomb of Catherine of Austria.

large bequest to San Lorenzo and requested burial in the church [Fig. 54]. At the end of that same year, the death of Giovanni di Capua stimulated the extension of the church to the west in order to create three di Capua family chapels at the southwest termination of the nave. During this process, the nave arcade was dismantled and its columns transferred between the chapels, thus creating one large interior volume [Fig. 55]. A heavier exterior wall, thickened by secondary arches above these columns, was erected to a great height to support the vast wooden truss ceiling that covered the new span of the nave [Fig. 51]. At the same time, and in order to coordinate the huge volumes of the new wide nave with those of the Gothic apse, a transept was inserted between the old basilica and the new choir; high walls were erected to create the type of tall "box" transept, similar to that at the cathedral and at Sant'Eligio. In this dramatic reconstruction, the nave was transformed from an aisled basilica into one large interior volume with a new facade.

This ambitious and daring project, which voided out the exterior envelope of the earlier church, was not without precedent within the Franciscan Order. Franciscan builders

were accustomed to working in the densely inhabited centers of cities and were forced by economic and topographical circumstances to find creative and inventive solutions to the enlargement of their churches. The great protonotary of the kingdom, Bartolomeo di Capua, who patronized this last transformation of the church of San Lorenzo, was commemorated by the placement of his family coat of arms in various strategic positions in the church, as D'Engenio Caracciolo put it: *"dappertutto nella chiesa."* This noteworthy family, whose palace is on the south side of the city block in which San Lorenzo is located, is an example of the kind of noble patronage that endowed the new mendicant orders, although Bartolomeo himself was buried at the cathedral of Naples.

The building history of San Lorenzo is in many ways exemplary of the changes in Franciscan architecture in its first century in Italy. Saint Francis himself had taken to repairing old churches and adapted several for the

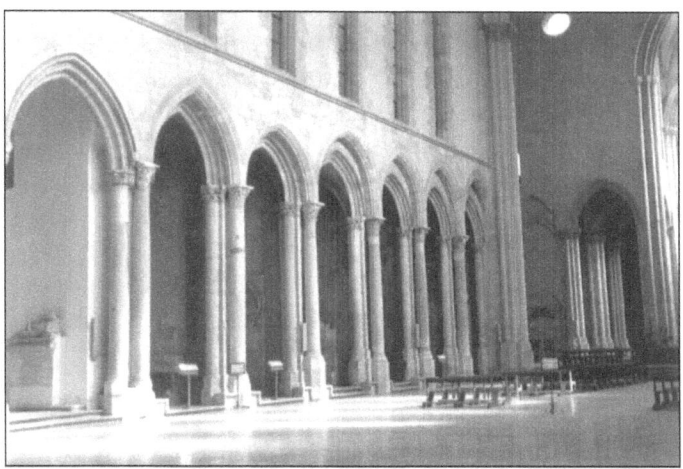

*Fig. 55. San Lorenzo, detail of nave wall.*

use of his followers (the Porziuncula and San Damiano near Assisi). In Naples, the donation of the sixth-century basilica of San Lorenzo to the order in 1234 was consonant with this practice. Franciscan communities grew rapidly almost everywhere, and at San Lorenzo in Naples anecdotal evidence puts the number of friars at around 100 by the end of the thirteenth century. Neither the old basilica nor the additional chapels along the nave would have been sufficient to serve the large monastic and lay community attached to the church, which explains the need to enlarge the church to the east and west.

*See web gallery 100116.*

When we turn to the history of San Domenico, the narrative is far less rich. The site given to the Dominican friars was a hospital and small chapel. In 1284, Charles II, while still prince of Salerno, made a major donation for the construction of a new and much larger church [Fig. 56]. The monastic complex was rebuilt in the Aragonese period, however, and the church, badly damaged by earthquakes and heavily restored on several occasions, was covered in the nineteenth century by a thick layer of stucco and medievalizing decoration. Only the main portal (located to the north, Fig. 57) attests to the refinement and elegance of the original medieval building. This portal was a donation of Charles of Calabria, the heir to the throne, in 1325. The utilization here of two colors of marble to create a refined intarsia pattern is highly unusual in Naples and relates most closely to the portals of the baptistery of Siena Cathedral, dated to the 1320s.

### Tuscan Artists in Naples

The presence of a Sienese master engaged in the completion of San Domenico testifies to the important role of Tuscan

artists in Naples, especially of Tino di Camaino and his workshop. Tino was invited to Naples in 1323 to execute the tomb of Catherine of Austria, which still survives to the south of the main altar at the Franciscan church of San Lorenzo [Fig. 54]. As Francesco Aceto noted in 1995, the tomb of Catherine was modified, probably by the sculptor himself prior to his death in 1339, to fit into its present

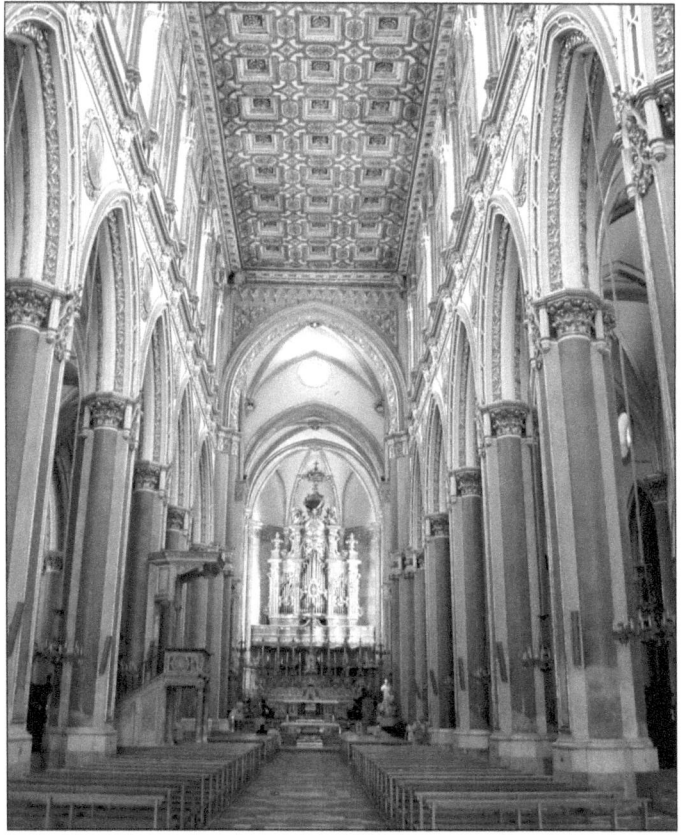

*Fig. 56. San Domenico, view of the interior.*

location squeezed between two of the hemicycle columns. The monument was probably first conceived of as against a wall rather than free-standing. Its reconfiguration was perhaps the result of the transformations to the architecture of the church that began a year after the queen's death, in the mid- to later-1320s, as described above. Catherine's tomb was soon followed by that of the dowager queen, Mary of Hungary, who died in March 1323 and whose tomb at Sta. Maria Donnaregina [Fig. 78] was carved soon afterwards. These two tombs by Tino initiated a type of monument in Naples that was to continue for decades and that spread throughout the kingdom to other cities, such as Gerace and Mileto in Calabria. An effigy, placed on top of a sarcophagus supported by the personifications of virtues, was surmounted by a canopy. Above the effigy angels pull back curtains to expose the sleeping figure of the deceased. The tombs were normally placed against a wall, but as noted above, that of Catherine of Austria was modified into a free-standing structure with a passage underneath.

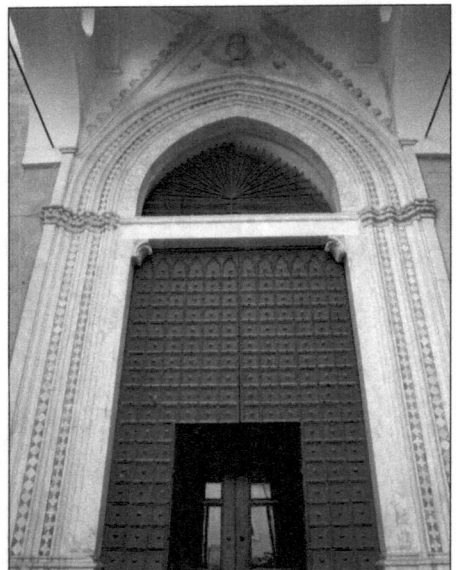

*Fig. 57. San Domenico, the main portal.*

Whereas Queen Mary of Hungary (d. 1323) was buried at Sta. Maria Donnaregina, and other members of the royal family were interred at San Domenico, the largest surviving groups of Angevin tombs are those in the cathedral and in Sta. Chiara. At Sta. Chiara those of Mary of Valois (d. 1328), Charles of Calabria (d. 1328), and Robert the Wise (d. 1343, Fig. 58) were executed either by Tino's workshop or by new Tuscan artists, in the case of King Robert's tomb, Giovanni and Pacio Bertini from Florence.

Fig. 58. Sta. Chiara. Tomb monument of Robert of Anjou.

See web gallery 100120.

In this connection, it is worth recalling that the Umbrian artist Montano d'Arezzo had been employed in the first decade of the fourteenth century to work at San Lorenzo and Montevergine. Tuscan and Umbrian painters were also employed at the Clarissan convent of Sta. Maria Donnaregina, reconstructed beginning in 1297 with financial support from Queen Mary of Hungary, and at the Brancaccio Chapel at San Domenico, the Minutolo Chapel of the cathedral c.1300/1301, and at the great double convent

of Sta. Chiara. The paintings at Donnaregina, a monumental cycle dedicated to the life of Saint Elizabeth of Hungary, the Passion and Saint Catherine of Alexandria, date to the second and perhaps third decade of the fourteenth century [Fig. 59]. They have been attributed to Pietro Cavallini and his school. In addition, Giotto was employed by King Robert to decorate the royal chapel at Castel Nuovo and the nuns' choir at Sta. Chiara, both in the late 1320s, but unfortunately only small fragments survive.

*See web gallery 100052.*

### Naples Becomes a Capital

In the decades after the outbreak of the War of the Vespers in 1282, it must have become increasingly clear that Palermo could never again be considered the central focus of the kingdom and its primary administrative center. The construction of Castel Nuovo by Charles I, begun in 1279, and the moving of the archive and mint to Naples seem to have initiated a process of concretizing the idea of this city as a capital, a situation confirmed and consolidated by Charles II (1288–1309). The shift was reflected in a number of public works undertaken in the city, as well as the increasing numbers of royal burials in the various (mostly mendicant) churches of Naples.

*See web gallery 100044.*

*See web gallery 100243.*

Castel Nuovo [Fig. 77] was one of a network of fortifications that were placed on the periphery of the city, none of which, unfortunately, survives in its medieval state. Castel Belforte (now known as Sant'Erasmo) above the city, on the Vomero Hill, was rebuilt in 1329 by King Robert the Wise over an earlier Norman structure to enhance protection of the city below. Open to the public, it provides one of the best

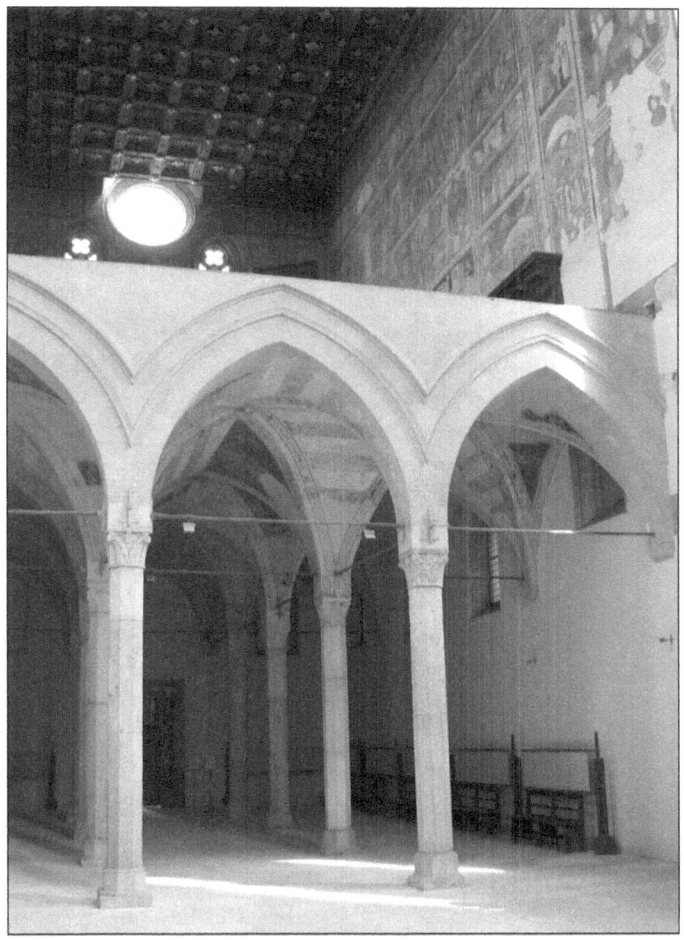

*Fig. 59. Sta. Maria Donnaregina, the nuns' choir.*

views of the city. To the east of the ancient city, the older Castel Capuano erected under the Normans protected access to the city from the east. Until the erection of Castel Nuovo beginning in 1279,

*See web gallery 100255.*

the ancient Castel dell'Ovo, founded over one of the first sites of Greek occupation in the city, remained the chief seaward fortress. In the early Middle Ages the site was occupied by a Basilian monastic community and took the name of San Salvatore, and by the Norman period it was already fortified. Under the Angevins, the castle was used as a royal residence, for the treasury and meetings of the royal curia and as a prison.

*See web gallery 100036.*

Beginning with his long-term return to Naples in 1294, Charles II undertook a series of major projects with the intent of monumentalizing the city as well as providing a better level of service and comfort. To that end, the king ordered the construction of a new and better port, developed sections of the city and enclosed them within the expanded city walls, paved roads, cleared swampy areas, repaired aqueducts and built an arsenal.*

*See Interactive Map.*

*\* See Documentary History, chap. 6, reading 1285.*

Charles II was above all famous for his concern for the spiritual welfare of his subjects. Everywhere in the kingdom he assisted in the reconstruction, repair or foundation of churches, hospitals and monasteries. Many of these projects were associated with the friars (above all the Dominicans, but also the Carmelites and Augustinians and, after 1296, the Franciscans), but equally large numbers were for the older and more established religious institutions, such as the historic and highly venerated shrine of the Virgin Mary at Montevergine. He also founded hospitals, a number of which were in and around Naples. The extent of his donations to churches and monasteries is staggering, and this king is surely one of the greatest royal patrons of religious architecture in the Middle Ages. It is probably no coincidence that during his rule the

Angevin crown became ever more heavily indebted to Florentine banking families, such as the Acciaiuoli, who came to play a major role in the kingdom in later years.

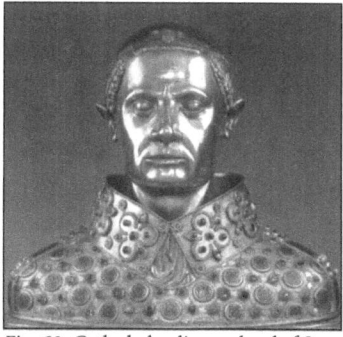

Fig. 60. Cathedral, reliquary head of San Gennaro.

In addition, Charles of Anjou patronized the fabrication of precious reliquaries for local saints and promoted their cults: he gave elaborate shrines to the church of San Nicola in Bari and, most famously, commissioned three French goldsmiths to produce a head reliquary of San Gennaro [Fig. 60] for the cathedral of Naples. Both are still in the treasuries of the respective churches. Charles II was also deeply devoted to Mary Magdalene, whose purported relics he had discovered in 1279 at what was to become the Dominican shrine of St.-Maximin-la-Ste.-Baume in Provence. A few years later he commissioned a golden reliquary for her skull at the shrine in Provence, and he subsequently initiated the construction of a large church at St.-Maximin in her honor. The cult of the Magdalene was actively promoted throughout the Kingdom of Sicily, and numerous churches and chapels were dedicated in her honor. In addition to the cult of Mary Magdalene, other saints of importance to the French or Provençal communities were venerated in the Kingdom of Sicily, as is indicated in the dedications of chapels and churches throughout the Regno (Sta. Maria Iacobi in Nola, for example).

*See web gallery 100059.*

*See Interactive Map.*

Charles II's patronage in Naples had a special character. The first project to be undertaken, in June 1294, was at the instigation of the archbishop of Naples, Filippo Minutolo: the reconstruction of the cathedral on a much grander scale than the previous basilica. The axis of the old church was rotated ninety degrees, so that the new apse was in the east [Fig. 61]. Part of the old church was absorbed into the much larger new cathedral and, indeed, the width of the new nave corresponds to the dimensions of the former atrium in front of Sta. Restituta. The new cathedral was parallel to via dei Tribunali, rather than at right angles to it, as its predecessor had been. This permitted the construction of a larger and longer church with a monumental character better suited to the concept of Naples as the new capital of the kingdom. But there were structural disadvantages to this realignment of the building: the south flank of the new cathedral is placed on a major fault line, a problem that in subsequent centuries was to cause structural failures, especially after the earthquakes of 1349 and 1456.

The new cathedral is important for its design. It has a tall, uninterrupted transept modeled on monuments, such as the early Christian basilicas of Rome (there had been no transept in its predecessor at the site, Sta. Restituta). Romano (2002) and Bruzelius (2004) have noted that the tall transept reflects Roman models, and therefore emphasizes the ancient (indeed, apostolic) origins of the episcopacy of Naples, which, according to legend, had been founded by Saint Peter. The theme of apostolicity is reflected not only in the tall transept, but also in the dedications and decoration of the Minutolo

and D'Ormont chapels, founded c.1300 and c.1315 respectively, consecrated to Saints Peter and Paul.

The importance placed on emphasizing historical continuity and tradition are also revealed in the piers of the cathedral, which integrate into their structure the ancient columns from the atrium [Fig. 62]. Columns were inserted into semi-circular concavities in the lower third of each pier, creating a vertical accent continued in the upper part of the piers by a shaft constructed in coursed masonry. This unusual disposition has historical counterparts in Campanian Romanesque architecture. Examples include the columns inserted into the crossing

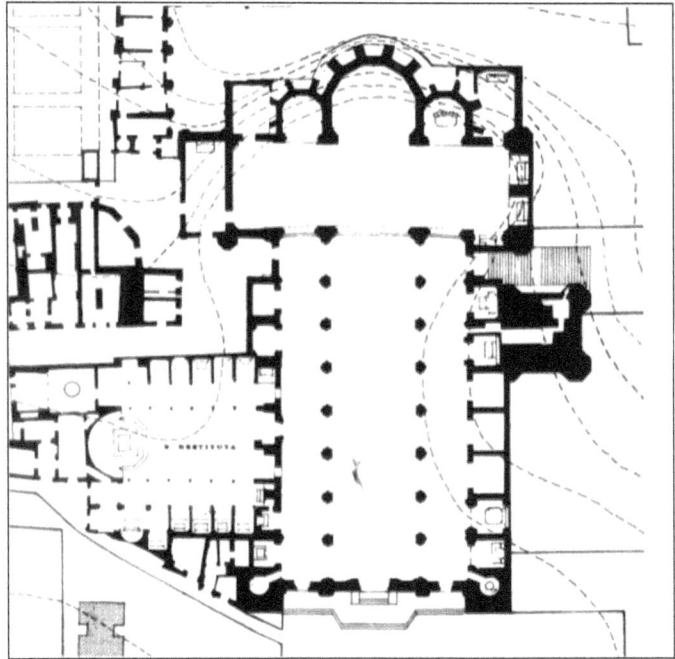

Fig. 61. *Cathedral, plan. De Stefano, 1974.*

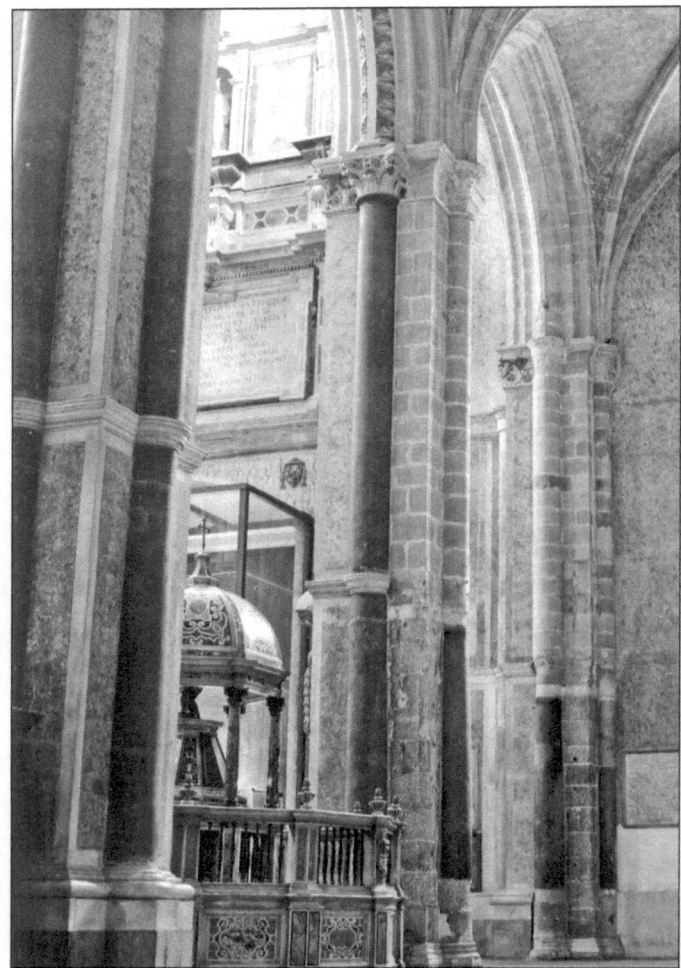

*Fig. 62. Cathedral, piers at the northwest end of the nave.*

piers at the cathedrals of Caserta Vecchia, Aversa and Sessa Aurunca. In Naples, though, this idea is extended throughout the entire church, integrating the use of

ancient materials into an architectural context on a much taller and grander scale than in any preceding building in Naples or, for that matter, in the other cathedrals just mentioned. The use of ancient columns recalls the long tradition of early Christian basilicas, especially those of Rome, but at the same time, since they are placed within the piers like jewels in a crown, they did not impose limitations on the height and scale of the new building. This was an important innovation in a city where — unlike Rome — there was not an abundance of monumentally scaled ancient columns available. The central point here, however, is the affinity between the new cathedral of Naples and the great Constantinian basilicas of Rome, which are evoked, however, in a somewhat modernized, Gothic form.

The retrospective character suggested by the cathedral of Naples, which looked to ancient traditions to convey the concepts of legitimacy and authority, has some reflections elsewhere. About 1300 the relics of Saint Severus in the church of San Giorgio Maggiore, just south of the cathedral, were translated to a new reliquary made from part of an ancient marble column. The medieval sculptor added rather clumsy fluting to an ancient column, presumably in an attempt to make the column–reliquary look "more ancient still." The column segment is placed horizontally, with a cavity carved out of its center for the relics, and closed with a "cap," which in Gothic script gives the name of Saint Severus. This highly unusual reliquary used ancient materials to convey the aura of venerable antiquity to the cult of an early Christian bishop–saint in much the same way that the ancient columns were re-used at the cathedral.

*See web gallery 100410.*

The apse of the cathedral was originally a polygon covered by a dome and lantern (Di Stefano 1975, Guidarelli 2005, 2008). It seems likely that this centralized space was originally conceived as a martyrium for San Gennaro, some of whose relics had been translated to the cathedral centuries before. The golden reliquary head [Fig. 60] commissioned by Charles II may initially have been intended to be located in this polygonal space, probably complete by c.1304/5 (Bruzelius 2004).

Yet the cathedral also served as a burial place for the new Angevin dynasty. At his death in 1285, Charles of Anjou was interred in the old basilica of Sta. Restituta, as was also his first wife, Beatrice, who died in 1267 (although her body was later moved to the reconstructed church St.-Jean-de-Malte in Aix-en-Provence). The new cathedral also had a monument to Charles II (d. 1309, buried partly at San Domenico in Naples and partly at Notre-Dame-de-Nazareth in Aix). Later on, the tombs of Charles Martel and Clemenza (both of whom had died in 1295) were executed in 1332/33 under the supervision of Queen Sancia of Majorca and were probably carved by Tino di Camaino. Although the evidence remains uncertain, it is possible that the royal tombs were located from the start in the apse of the cathedral, so that the royal family would have associated itself closely with the patron saint of Naples, San Gennaro. An alternative placement for the royal tombs may have been in the large rectangular "Roman" transept.

The cult of San Gennaro at the cathedral was embedded in a larger ideological program, already discussed, that emphasized the apostolic origins of the church. At the extremities of the east wall of the transept, on north and south, burial chapels were soon added for two of

Figs. 63. Cathedral, Minutolo Chapel.

Naples' contemporary bishops: to the right of the central apse, on the south, the chapel for Archbishop Filippo Minutolo [Figs. 63, 64a-b], dedicated to Saint Peter, founded c.1299/1300 to contain Filippo's tomb and as the memorial chapel for the Minutolo family. (It still serves this function.) On the left (north), the French archbishop, Umberto D'Ormont, commissioned a matching chapel dedicated to Saint Paul, founded and constructed c.1315–20 as the burial chapel for himself and his French predecessor, Aiglerius, the first French archbishop of Naples. Both chapels were decorated with important fresco cycles, the Minutolo chapel with scenes from the lives and martyrdoms of Peter and Paul. Filippo Minutolo is prominently displayed at the foot of the Crucifixion scene, introduced by Saint Peter and Saint Gennaro at his side. The fresco cycle has been attributed to Montano d'Arezzo, who was working at San Lorenzo at about the same time.

During the process of reconstructing the cathedral starting in 1294, the decision was made to preserve parts of the old double-aisled basilica of Sta. Restituta, traditionally attributed to the patronage of Emperor Constantine. The

*See web gallery 100423.*

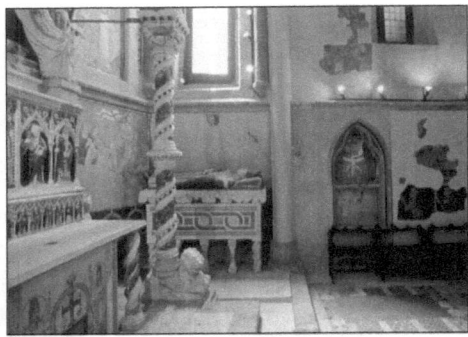

*Figs. 64a-b. Cathedral, Minutolo Chapel.*

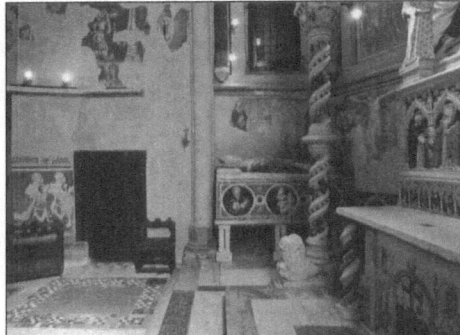

See web gallery 100423.

old church was remodeled with pointed arches in the arcade, and the outer aisles became a series of lateral chapels. As part of this process, the Umbrian artist Lello da Orvieto was commissioned to execute a mosaic for the chapel of Sta. Maria del Principio (a site associated with Saint Peter's conversion of the first bishop of Naples) that represents the Virgin and Child flanked by Saints Gennaro and Restituta.

The ambitious project of the new cathedral was thus an important element of the "capitalization" of Naples in the 1290s. The period after Charles II's liberation from his Aragonese captivity in 1288, but especially his return to Naples in 1294 after several more years of absence, saw the embellishment of Castel Nuovo (the chapel of Sta. Barbara was built at this point) and the development of the suburb of palaces and princely residences around the royal palace that was to center on the via

delle Corregge (Medina). At the same time, work started again on the incomplete projects of San Domenico and San Lorenzo, interrupted by the war of the Vespers of 1282. In the flurry of construction that Charles II initiated on his return to Naples, he also founded several other churches, such as San Pietro Martire and San Pietro a Castello, mostly for the Dominicans.

*See Interactive Map.*

At the same time, Queen Mary of Hungary became a major patron in the reconstruction of Sta. Maria Donnaregina, a convent church for the Poor Clares. This convent is one of the few of the new foundations to survive more or less intact (though heavily restored), and is one of two magnificent convent churches erected for the Clares by the royal family. Although most of the conventual structures at Donnaregina were destroyed when the via del Duomo was enlarged in the late nineteenth century, the early fourteenth-century church, probably erected between c.1307 and 1314, is a magnificent example of the Gothic style. The polygonal apse [Fig. 66] is preceded by a rectangular nave divided into two levels, the upper a choir reserved for the nuns and the lower a church open to the public [Fig. 59]. Groin vaults decorated with the painted arms of Anjou and Hungary support the upper gallery, and Mary of Hungary (d. 1325) is herself buried on the left side of the nave (it has been proposed that her tomb [Fig. 78] was originally located behind the altar in the apse). Sta. Maria Donnaregina is now mostly known for the ambitious cycle of frescoes that decorate the nuns' choir, a cycle attributed to the school or the circle of Pietro Cavallini. The frescos, generally dated 1317–19, were badly damaged in a late fourteenth-century fire but are nonetheless a precious testament to the importance of northern artists at work in Naples in the first and second decades of the fourteenth century. As noted above, Pietro Cavallini was already present in

*See web gallery 100052.*

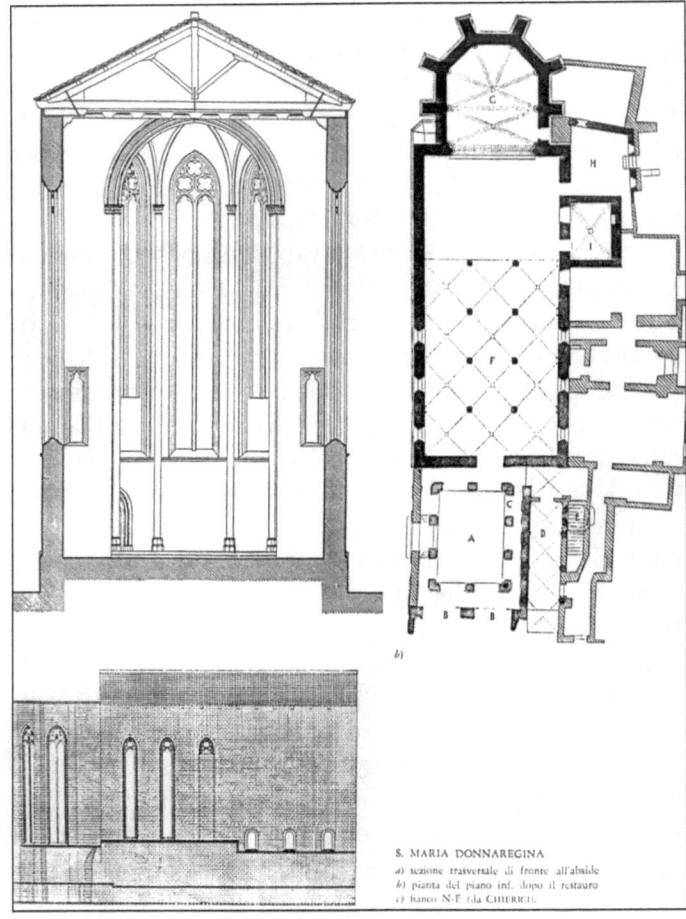

Figs. 65. Sta. Maria Donnaregina, plan and elevation.
From Venditti, in Storia di Napoli 3, Piante e Rilievi.

*See web gallery 100116, images 13–18.*

Naples c.1308, when he probably decorated the Brancaccio Chapel at San Domenico.

The church that may best express today the distinctive style of Angevin Gothic architecture is probably

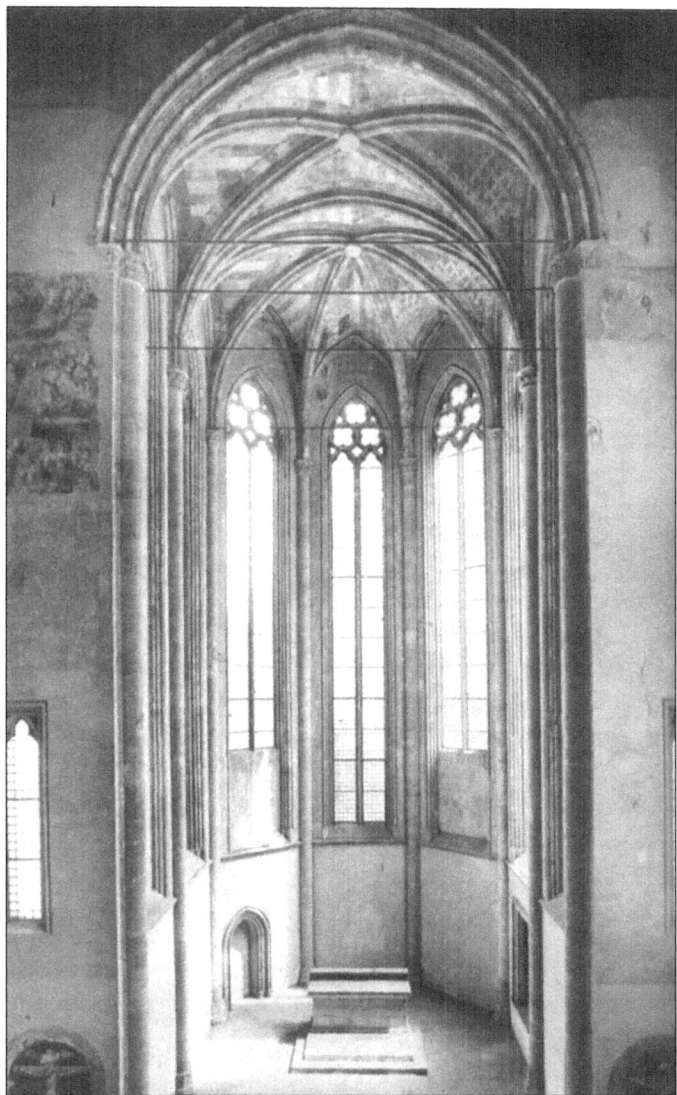

Fig. 66. Sta. Maria Donnaregina, apse.

*See web gallery 100075.* San Pietro a Maiella [Fig. 67], on the western side of the old center, a church begun probably c.1305–10 with the patronage of Giovanni Pipino da Barletta. Pipino was one of Charles II's chief administrators, notorious for his role in the suppression and extinction of the Muslim community at Lucera in August of 1300. He was also, however, an active patron of religious foundations, in Lucera and Barletta as well as in Naples, and seems to have had special veneration for Peter of Morrone, the pious hermit who became Pope Celestine V and abdicated the papal throne while in Naples in 1294. Peter of Morrone was founder of a reform branch of the Benedictines, the Celestines, who were known for their asceticism.

The church is located between the west end of the via dei Tribunali and extant buildings to the south. In its restored state, it illustrates the essential characteristics of the churches erected by Charles II (the cathedrals of Naples and Lucera, San Domenico in Naples): compound piers with attached shafts for the arcade arches and ribs of the side-aisles, a flat upper nave wall punctuated only by the windows of the clerestory and a wooden truss ceiling. The limpid geometry of the interior surfaces of this style would have been evident at the cathedral and San Domenico in Naples before subsequent redecoration and remodeling, and is still visible at the cathedral of Lucera.

## *The Angevin Reconfiguration of the City*

The construction of Castel Nuovo, which shifted the center of power southwest of the city, and the foundation of numerous and often very large convents for the new religious orders, had a profound impact on the city of Naples. Striking is the number, scale and centrality of the mendicant foundations, which consisted not only of

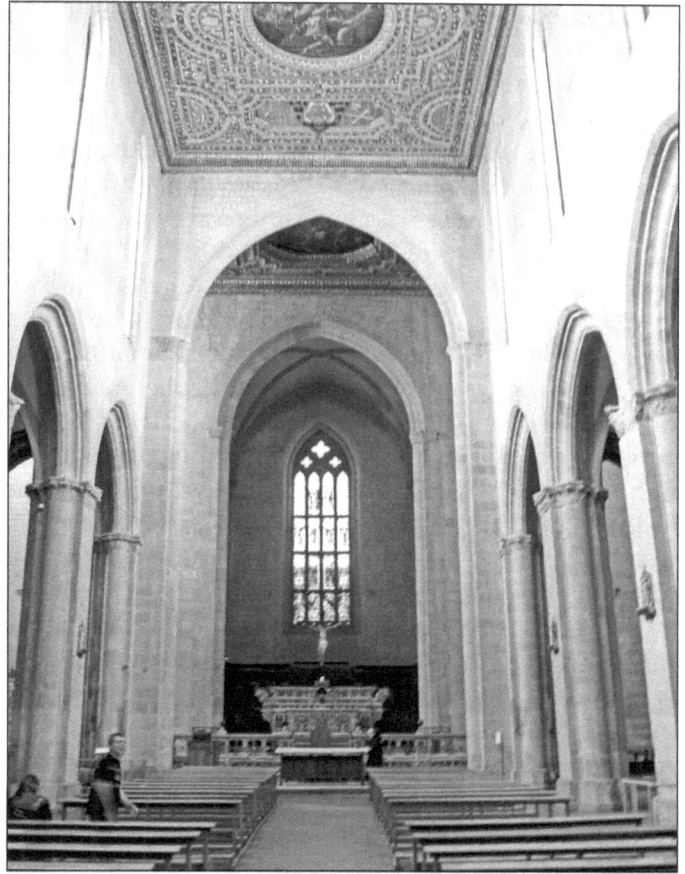

*Fig. 67. San Pietro a Maiella, view of the interior.*

the monumental churches of San Lorenzo, Sant'Agostino alla Zecca, Sta. Maria del Carmine, Sta. Maria la Nova, Sta. Maria Donnaregina, San Domenico and San Pietro Martire, but also, beginning in 1310, the massive complex of Sta. Chiara. There were also numerous smaller

churches, chapels, hospices and hospitals established by the pious confraternities and groups of tertiaries. Many of the new establishments were established either in the heart of the old city or as close as possible to its edges. With the exception of Sta. Chiara, many of these projects were initiated in the last decades of the thirteenth century, and as we saw, a significant number of them by Charles II and his wife.

One particular faction of the new religious movements had not, however, found support within the royal family, and that was the party of the Franciscan Order devoted to apostolic poverty and Joachite prophesy, known as the Fraticelli, or Spirituals. Their fervent adherence to the ideal of poverty and their absolute renunciation of possessions led to serious division within the Franciscan Order, and the rigorous Franciscans were often marginalized and persecuted. But the movement flourished and found numerous followers in Provence, southwestern France and Catalonia, as well as in Tuscany, Umbria and the Marches in Italy. In Naples the Spirituals were particularly important during the reign of Robert the Wise, for the marriage alliance between Aragon and Naples brought together two families in which the poverty- and apocalyptic-minded Franciscans had found not only comfort and protection, but also — especially in the person of Robert of Anjou's (c.1277–1343) second wife, Queen Sancia of Majorca (1286–1345) — an extraordinary level of patronage (Musto 1985, 1997).*

*See Documentary History, chap. 6, reading 1334, July 25.

Interest in, and support for, the Spiritual Franciscans found expression in the foundation of the massive double convent of Sta. Chiara, initially dedicated to Corpus Domini [Fig. 68]. Documentation for the foundation

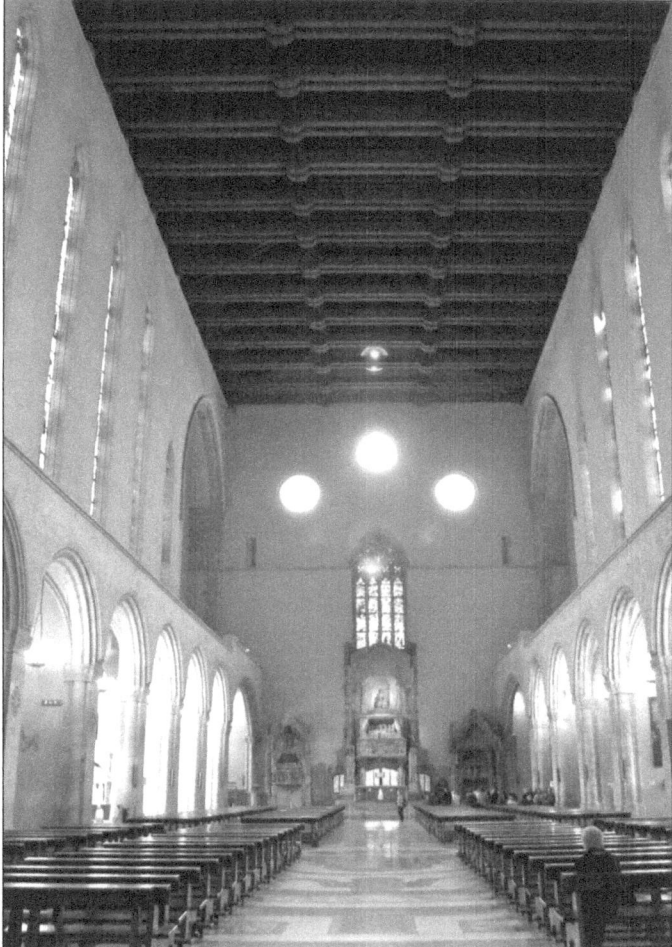

*See web gallery 100120.*

Fig. 68. Sta. Chiara, view of the interior.

suggests it was above all the project of Queen Sancia. The couple succeeded to the throne after the death of Charles II in 1309 and the papal decision to affirm Robert's candidacy against the claims to the throne from the heirs

of Charles Martel, king of Hungary and Robert's older brother, who had died in 1295. Queen Sancia of Majorca had passed her youth in Perpignan and Montpellier and her family, especially her mother, Esclaramonde de Foix, was closely allied with the Spiritual Franciscans.

The vast church of Sta. Chiara, initiated in 1310 as a massive double convent for Clares and Franciscans, had two cloisters, one for the friars on the southern side of the lower decumanus, at the end of what is now via Benedetto Croce, and the other, much larger, for the nuns, deeply embedded in the large city block that forms the monastic complex [Fig. 69]. The entrance to the complex focused on the street, with the result that the church has its altar to the south, towards the port and Castel Nuovo. The nuns' choir was located between the large cloister and the main altar; the nuns could thus have direct vision of the Mass and the consecrated host through the three large flanged windows between these two parts of the structure [Fig. 70]. As in all Clarissan houses, the women were to live in strict enclosure, a state of complete separation from the world that had recently been reaffirmed by Boniface VIII in the bull *Pericoloso*, issued in 1300. As far as the veneration of the Eucharist was concerned, however, Sancia's convent was designed with far greater permeability than the pope had envisioned, for the visual relationship between the altar and the choir of the sisters was close and intimate. This probably reflected Sancia's deep devotion to the consecrated host (Bruzelius 1995).

Robert the Wise was above all a patron of intellectuals, poets, including Petrarch, and painters. It was during his rule that Giotto was brought to Sta. Chiara (1328–29) to decorate the nuns' choir with an Apocalypse cycle. Between

Fig. 69. Sta. Chiara, plan. From Dell'Aja, 1980.

1330 and 1331 Giotto may also have been employed in the painting of the Cappella Sta. Barbara in Castel Nuovo and subsequently (1332–33) in a cycle of famous men based on texts by Petrarch (and perhaps also famous women) in Castel Nuovo. Tragically, only small fragments of these large programs survive: part of a Deposition can be seen in the choir of Sta. Chiara, and tiny portions of the frescos from the Cappella Sta. Barbara were

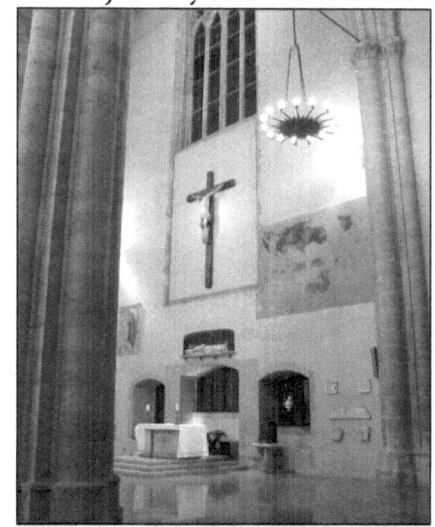

Fig. 70. Sta. Chiara, nuns' choir toward the altar.

*See web gallery 100044.* recovered in recent excavations at Castel Nuovo (Palmieri 1999).

It is not clear whether Sta. Chiara was intended from the outset to become the necropolis of the Angevin royal dynasty, but by the late 1320s it became so with the burial of Prince Charles of Calabria's infant daughter and then with the prince's tomb and that of his wife, Mary of Valois, both of whom died in 1328. These tombs were carved, as had now become standard, by Tino di Camaino and his workshop. In 1343, with the death of Robert, the role of Sta. Chiara as the royal necropolis was affirmed by his large tomb, carved by Pacio and Giovanni Bertini, placed directly behind the main altar on the central axis of the church [Fig. 58]. The project was commissioned by Robert's heir, Queen Giovanna I.

Sadly, the bombardments of 1943 seriously damaged the church and these tombs, and Robert's in particular is a mere fragment of the original majestic composition. The prominent location of the tomb, directly behind the altar, though striking, was not at this date entirely new: Emperor Henry VII had been provided with a monumental tomb behind the altar at the cathedral of Pisa in 1313, and perhaps Mary of Hungary's tomb, as well as the royal tombs in the cathedral of Naples, were also in the main sanctuary of their respective churches, behind the main altar. But Robert's tomb seems to have far surpassed all these in complexity and scale, for there are four images of the king both in effigy (as a barefoot Franciscan friar) and enthroned on the sarcophagus and above. The tomb was supported by female figures of the Virtues, while the sarcophagus itself was carved with portraits of the royal family.

Queen Sancia was not buried at Sta. Chiara, though this may have been her original intention when the

church was founded. Prior to her death in 1345, she chose to be inhumed at her more recent foundation to which she had retired a year after Robert's death, the much smaller church of Sta. Croce, founded slightly to the west of Castel Nuovo. Her tomb, now destroyed, has been preserved in drawings by Seroux d'Agincourt in the Vatican Library [Fig. 71]: they show the two sides of the

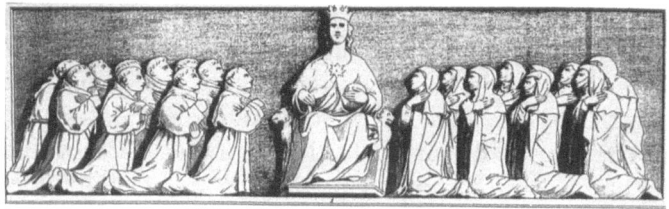
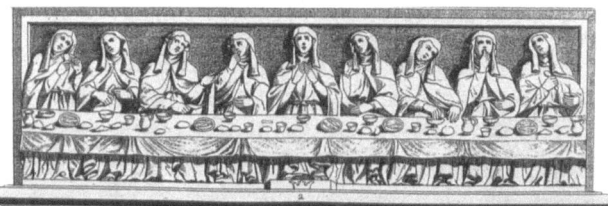

Fig. 71. *Seroux D'Agincourt, drawings of the tomb of Sancia of Majorca*

sarcophagus as representing the queen in the middle of a ritual meal with her religious community, and, on the other side, enthroned and flanked by groups of nuns and friars. Without question the queen in this program was emphasizing her role both as founder and member of a religious community.

In 1325 the heir to the throne, Charles of Calabria, founded the Charterhouse of San Martino on the crest of the Vomero Hill beside the Castle of Sant'Elmo. The choice of the Carthusians, an older monastic order founded by Saint Bruno of Cologne in 1084, was an unusual choice at a time when the new religious movements

*See web gallery 100177.*

based on the idea of mendicancy and preaching were so much in vogue. The prince may have been influenced by the foundation of the splendid Carthusian monastery founded by Tommaso di Sanseverino at Padula in 1309. Only fragments of windows and portals survive of the medieval complex, which has now become a museum dedicated in part to the topography of Naples.

Although scholarship has concentrated on the role of the royal family in artistic patronage, the preceding pages have demonstrated the importance of the noble and mercantile civic elite in the foundation and decoration of churches and palaces. In this connection we should mention some important noble patrons of Neapolitan monuments, first and foremost the great protonotary, Bartolomeo di Capua. Bartolomeo, the effective equivalent of chancellor of the realm, was instrumental in the completion and foundation of numerous architectural projects and foundations. He had a role in the reconfiguration of San Lorenzo after 1324, as we have seen. He financed the major portal of the church of San Domenico in 1325 [Fig. 57]. He also founded the Neapolitan church of Sta. Maria di Montevergine (Monteverginella) in 1314, of which there are no medieval remains. He was also an important patron of churches and hospitals in Capua and elsewhere in Campania. Everywhere we can identify his patronage, we recognize a style that is a refined and up-to-date version of Tuscan models, as can be seen in the portals at San Lorenzo and San Domenico.

*See web gallery 100146.*

At the end of Robert the Wise's reign, in 1343, the church of San Giovanni a Carbonara was founded for the Austin (Augustinian) friars. The name of the foundation derives from the use of the site below the church as a refuse dump outside the city walls. At the death of King

Fig. 72. San Giovanni a Carbonara, tomb of King Ladislao.

Ladislao in 1414, the king's sister, Giovanna II, commissioned a magnificent tomb that still dominates the central

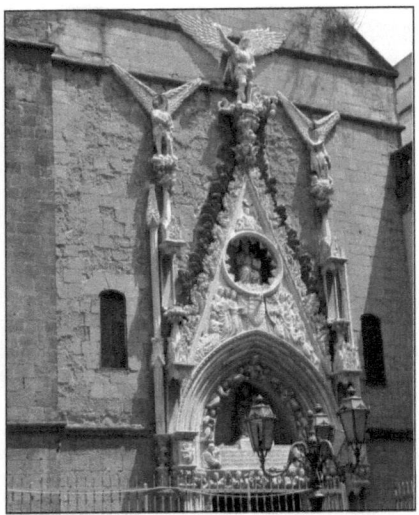

Fig. 73. San Giovanni a Pappacoda.

space of the nave [Fig. 72]. This tomb brings to new and extravagant dimensions the concept of the royal sepulcher placed behind the altar, and the entire composition is crowned by an equestrian figure of Ladislao bearing a sword. At the base of this tomb, behind the main altar, a portal gives access to the magnificent octagonal Caracciolo del Sole Chapel, where the unfinished tomb monument of Sergianni Caracciolo (d. 1432) is placed. The chapel is frescoed with scenes of the lives of hermits by Perrineto da Benevento and Leonardo da Besozzo, who painted the scene of the Coronation of the Virgin over the entrance door.

The sculpture and painting in the church of San Giovanni a Carbonara attest to the persistence of a late Gothic court style infused with Renaissance ideas brought in from Tuscany and elsewhere. This last phase of Angevin art is deeply hybrid in character, as can be seen most powerfully in the tomb of Ladislao, where Renaissance and Gothic elements intermingle to produce a tomb that is redolent of the values of court art as well as references to the new neoclassical style emerging in Florence and elsewhere. The result is a somewhat perplexing mix of two visual languages that are not yet brought into harmonious

equilibrium but that are typical of the fragments of late medieval/early Renaissance monuments in the city. A striking example is Antonio Baboccio's reconfiguration of the main portal of the cathedral (a repair of an earlier portal, probably by Tino di Camaino, damaged in the earthquake of 1349), which reused Tino's earlier elements (the lions at the base of the portal, for example). Antonio Baboccio also executed the portal of San Giovanni a Pappacoda, 1415, in an exuberant style that dominates the entire façade of this small church [Fig. 73]. Baboccio can be seen as the last major artist working in a medieval tradition in Naples and its surroundings, and his tomb in Salerno for Margaret of Durazzo, d. 1412, as well as the Aldomoresco tomb (1421) in San Lorenzo Maggiore and various tombs in Sta. Chiara are among his last works for the court. These tombs maintain the formula established by Tino di Camaino a century earlier while updating the sculptural style of the sarcophagus as a continuous relief.

*See web gallery 100059, images 3–7.*

*See web gallery. 100138.*

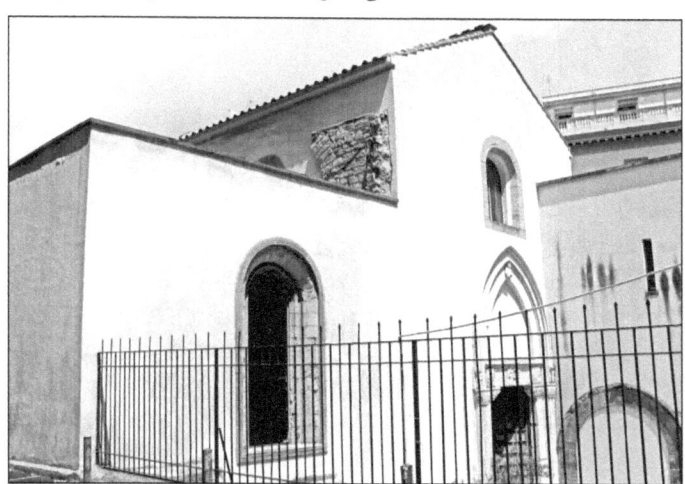

*Fig. 74. Sta. Maria Incoronata, west facade.*

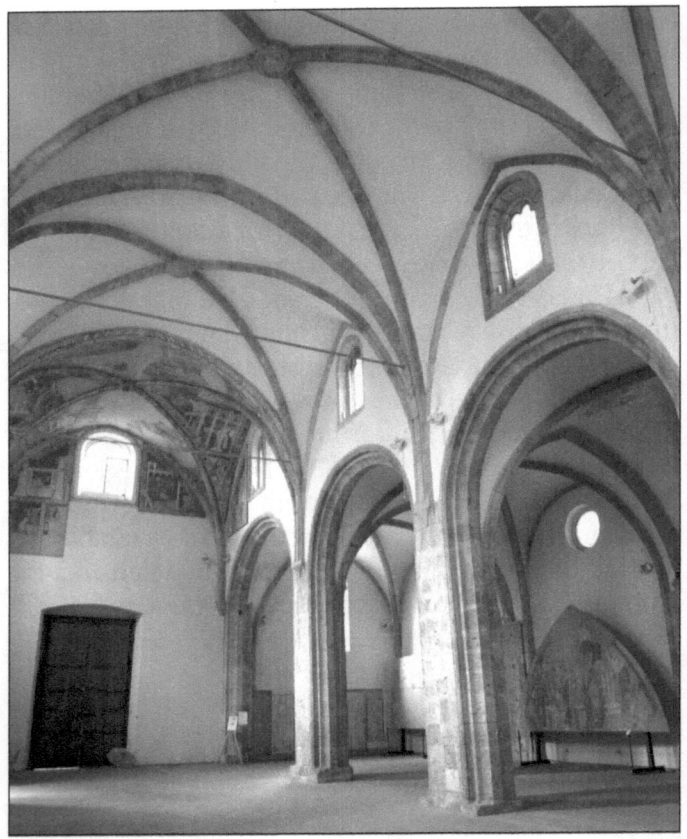

*Fig. 75. Sta. Maria Incoronata, nave.*

On the whole, however, art and architecture in Naples, which had flourished up until the deaths of Robert and Sancia, decreased dramatically in quantity and quality after their deaths. Queen Giovanna I fled briefly to Avignon during 1348 to escape the invasion of her cousin Lewis of Hungary, and the vicissitudes, as well as the economic crisis, of her reign, were serious impediments to a continued

flourishing of the visual arts. The one notable exception is the church of the Incoronata [Figs. 74–76], a hospital church founded in the 1360s by Giovanna I that is located between the old city and Castel Nuovo (Paola Vitolo 2008) on the via delle Corregge. The church consists of two parallel naves, a type of architecture frequently found in hospitals, with some precedent in the papal audience hall at Avignon. It was decorated by Roberto di Oderisio in the 1360 and 1370s with two fresco cycles, one of Old Testament justice scenes and one of the Seven Sacraments.

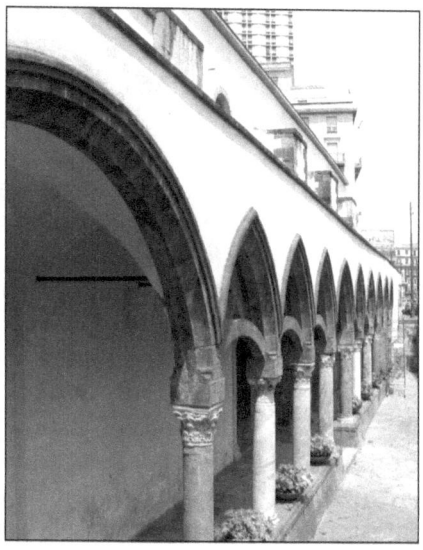

*See web gallery 100122.*

Fig. 76. Sta. Maria Incoronata, loggia.

Elsewhere, although some construction projects continued, and there are fragments of decorative programs in architecture and sculpture — especially tomb sculpture, as we have noted — for the most part the remainder of the fourteenth century has been viewed as a tragic period of Neapolitan history, with little by way of material remains that attest to the continued cultural vitality of the city. Some of the energy passed to other patrons and other cities in the kingdom. One might point, for example, to the church of Sta. Maria della Consolazione in Altomonte (Calabria), the churches founded by the Orsini family in Nola, or the

tombs in Teggiano (Campania) and Gerace (Calabria) as demonstrations of continued noble and courtly art patronage in the provinces, but it was not until the early fifteenth century and the court of Ladislao and Giovanna II that a strong and identifiable court culture re-emerged gloriously — if ephemerally — in the kingdom of Naples.

The art of late medieval Naples can be characterized as essentially conservative, a phenomenon that can be perhaps explained as the result of a court culture frequently under external threat (from the Hungarians and the Aragonese) and that used art as a means of reinforcing ideas of nobility, authority and continuity. It is therefore not surprising that Antonio Baboccio was brought down from the court of Milan by Cardinal Enrico Minutolo. It is only with the arrival of Alfonso of Aragon, and his clear decision to distinguish himself from the earlier regime, that the Renaissance style is fully adopted in Naples, and this most gloriously in the triumphal arch of Castel Nuovo, 1453–68 [Fig. 77].

■

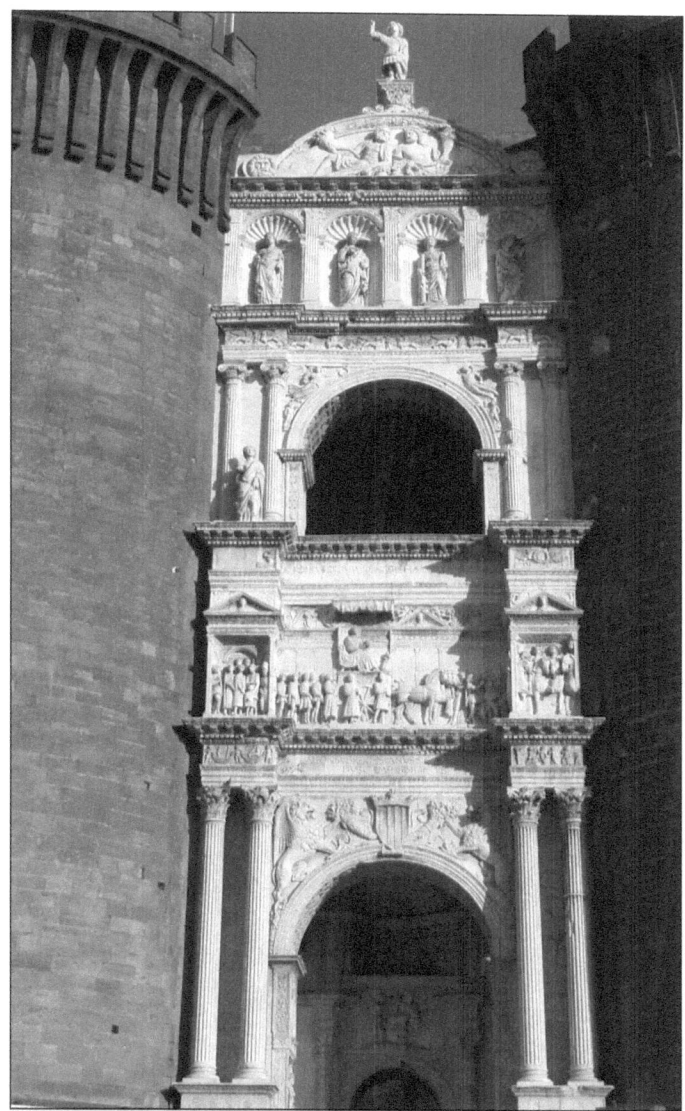

*Fig. 77. Castel Nuovo, triumphal arch of Alfonso I.*

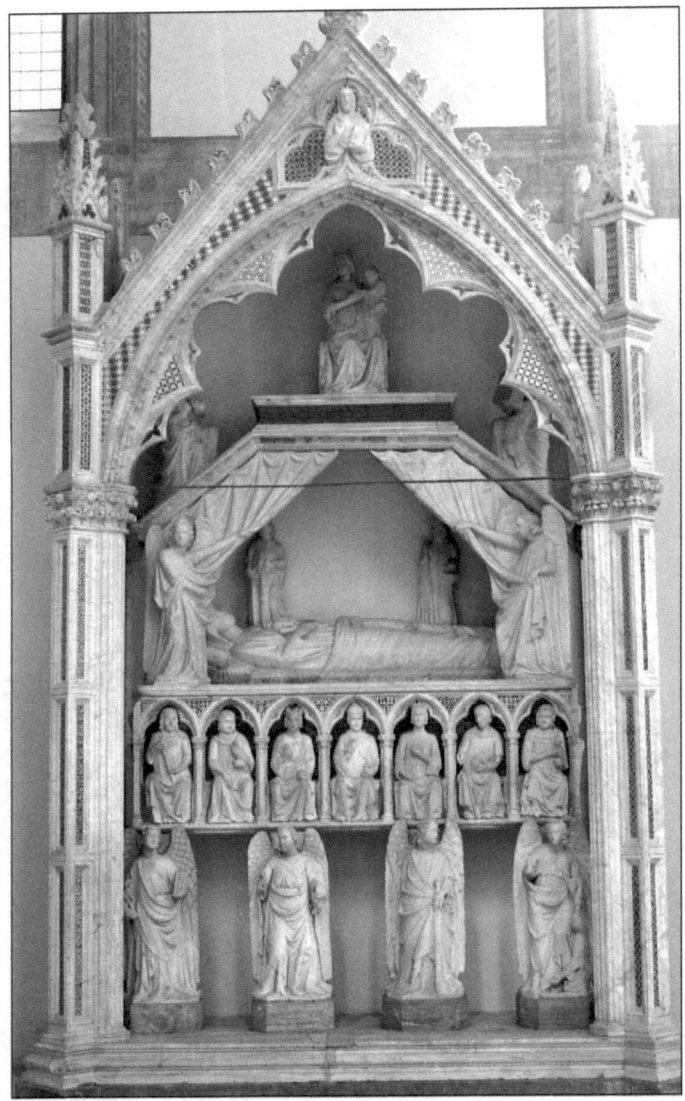

*Fig. 78. Sta. Maria Donnaregina, tomb of Mary of Hungary.*

# BIBLIOGRAPHY

*This bibliography offers a selective list of works intended to provide a solid background to Naples' related history, urban development and major monuments. It is arranged by period, and then by author and publication date. For complete bibliographies, with ongoing supplements, see* A Documentary History of Naples. 2: Medieval Naples, 400–1400, *at http://www.italicapress.com/index346.html.*

## General and Multiperiod

ALIM: *Archivio della latinità italiana del medioevo.* Rome: Unione Accademica Nazionale, 1996–. (http://www.uan.it/notarili/alimnot.nsf).

Benjamin, Walter. "Naples." In *Reflections: Essays, Aphorisms, Autobiographical Writings.* Peter Demetz, ed. New York: Harcourt Brace Jovanovich, 1978, 163–73.

Bologna, Ferdinando. "Momenti della cultura figurata nella Campania medievale." In Carratelli, 171–275.

Capasso, Bartolommeo. *Topografia della città di Napoli nell'XI secolo.* Naples: Arte Tipografica di A.R. San Biagio dei Librai, 1895; reprint Naples: Arnaldo Forni Editore, 2005.

Carratelli, Giovanni Pugliese, ed. *Storia e civiltà della Campania: Il medioevo.* Naples: Electa, 1992.

Cavallo, Guglielmo. "La Cultura Greca: Itinerari e segni." In Carratelli, 277–92.

D'Andrea, Gioacchino. "Chiese francescane nella città di Napoli." *Archivum Franciscanum Historicum* 87 (July–Dec 1994): 447–76.

Davis-Weyer, Caecilia. *Early Medieval Art 300–1150: Sources and Documents.* Toronto: University of Toronto Press in association with the Medieval Academy of America, 1986.

De Leo, Pietro. *Mezzogiorno medioevale: Istituzioni, società, mentalità.* Soveria: Rubbettino, 1984.

Del Treppo, Mario. *Storiografia nel Mezzogiorno.* Naples: Guida, 2006.

De Seta, Cesare. *Cartografia della città di Napoli: Lineamenti dell'evoluzione urbana.* Naples: Edizioni scientifiche Italiane, 1969.

—. *Storia della città di Napoli dalle origini al Settecento.* Rome: Laterza, 1973.

—. *Napoli fra Rinascimento e Illuminismo: Storia della città.* Naples: Electa Napoli, 1997.

—. *Napoli (Le città nella storia d'Italia).* Rome and Bari: Laterza, 2004.

Di Mauro, Leonardo. *La Tavola Strozzi.* Le bussole 1. Naples: E. De Rosa, 1992.

Di Stefano, Roberto, and Silvana Di Stefano. *La cattedrale di Napoli: Storia, restauro, scoperte, ritrovamenti.* Naples: Edizione Scientifica, 1975.

Esch, Arnold. "Spolien: Zur Wiederverwendung antiker Baustücke und Skulpturen im mittelalterlichen Italien." In *Archiv für Kulturgeschichte* 51 (1969): 1–64.

Favro, Diane. "Naples." In *The Dictionary of Art.* Jane Turner, ed. 34 vols. New York: Grove, 1996, 22:469–87.

Ferraro, Italo, ed. *Napoli: Atlante della città storica.* 6 vols. to date. Naples: CLEAN, Oikos, 2000–.

Filangieri, Riccardo. "Report on the Destruction by the Germans, September 30, 1943, of the Depository of Priceless Historical Records of the Naples State Archives." *American Archivist* (1944): 252–55.

—. et al., eds. *I registri della cancelleria angioina.* Naples: Archivio di Stato, 1950–2010.

Frugoni, Chiara. *A Distant City: Images of Urban Experience in the Medieval World.* Princeton: Princeton University Press, 1991.

Galasso, Giuseppe. *Storia del regno di Napoli.* Turin: UTET, 2006.

—. *Medioevo Euro-Mediterraneo e Mezzogiorno d'Italia: Da Giustiniano a Federico II.* Rome: Laterza, 2009.

Giampaola, Daniela, Vittoria Carsana, and Beatrice Roncella, eds. *Napoli, la città e il mare. Piazza Bovio: Tra Romani e Bizantini.* Milan: Electa, 2010.

Guillon, André, ed. *Il Mezzogiorno dai Bizantini a Federico II.* Turin: UTET, 1983.

Lucherini, Vinni. "Saggi: L'invenzione di una tradizione storiografica: Le due cattedrali di Napoli." *Prospettiva* (2004): 2.

—. *La cattedrale di Napoli: Storia, architettura, storiografia di un monumento medievale.* Rome: École Française de Rome, 2009.

Mazzoleni, I(J)ole. *I registri della cancelleria angioina, ricostruiti da Riccardo Filangieri* 4 (1266–1270). Naples: Accademia Pontaniana, 1952.

Musto, Ronald G. "Naples: Art Life and Organization." In Jane Turner, ed. *Encyclopedia of Italian Renaissance and Mannerist Art.* 2 vols. New York: Macmillan–Grove, 2000, 2:1130–31.

—. "Google Books Mutilates the Printed Past." The Chronicle Review. *The Chronicle of Higher Education.* June 12, 2009, B4–5.

Norman, Diana. "The Succorpo in the Cathedral of Naples: 'Empress of All Chapels'." *Zeitschrift für Kunstgeschichte* 49 (1986) 323–55.

Peduto, P. "Archeologia medievale in Campania." *La voce della Campania: Cultura materiale, arti e territorio in Campania* 7.10 (1979): 247–62.

Porter, Jeanne Chenault. *Baroque Naples: A Documentary History, 1600–1800*. New York: Italica Press, 2000.

Romano, Serena, and Nicolas Bock, eds. *Il duomo di Napoli dal paleocristiano all'età angioina*. Naples: Electa, 2002.

—. *Le chiese di San Lorenzo e San Domenico: Gli ordini mendicanti a Napoli*. Naples: Electa, 2005.

Samaran, C.S. "Les registres angevins de Naples." *Bibliothèque de l'Ecole de Chartes* 115 (1957):192–93.

Santore, John. *Modern Naples: A Documentary History, 1799–1999*. New York: Italica Press, 2001.

Santoro, Lucio. *Le mura di Napoli*. Rome: Istituto Italiano dei Castelli, 1984.

*Storia di Napoli*. Ernesto Pontieri, ed. 6 vols. Cava di Tirreni: Officine grafiche di Mauro, 1967–74.

Tramontana, Salvatore. *Il Mezzogiorno medievale: Normanni, Svevi, Angioini, Aragonesi nei secoli XI–XV*. Rome: Carocci, 2000.

## Late Antiquity

Achelis, Hans. *Die Katakomben von Neapel*. Leipzig: n.p., 1935–36.

Arthur, Paul. *Naples: From Roman Town to City–State. An Archaeological Perspective*. Archaeological Monographs of the British School at Rome 12. London: British School at Rome, with the Dipartimento di Beni Culturali, Università degli Studi di Lecce, 2002.

Capasso, Bartolommeo. *Napoli greco–romana*. Naples: Arte Tipografica di A.R. San Biagio dei Librai, 1905; reprint, Arturo Berisio Editore, 1987.

Cassandro, Giovanni. "Il ducato bizantino." *Storia di Napoli* 2.1:1–408.

Cortese, Nino. *Cultura e politica à Napoli del Cinque al Settecento*. L'Acropoli 14. Naples: Edizioni scientifiche italiane, 1965.

Döpp, Wolfram. *Die Altstadt Neapels: Entwicklung und Struktur*. Marburg: Geographisches Institut, 1968.

Fasola, Umberto M. *Le catacombe di S. Gennaro a Capodimonte*. Rome: Editalia, 1975.

Fuiano, Michele. *La cultura a Napoli nell'alto medioevo*. Naples, Giannini, 1961.

Galasso, Giuseppe. "La città campane nell'alto medioevo." In *Mezzogiorno medievale e moderno*. Giuseppe Galasso, ed. Turin: Einaudi 1965.

Greco, Emanuele. "L'Urbanistica." In *Neapolis: Atti del XXV Convegno di Studi sulla Magna Grecia 1985*. Taranto: n.p., 1986, 187–302.

Guillou, André, and F. Burgarella. *L'Italia bizantina: Dall'esarcato di Ravenna al tema di Sicilia*. Turin: UTET, 1988.

Hodges, Richard, and Brian Hobley. *The Rebirth of Towns in the West, AD 700–1050*. London: Council for British Archaeology, 1988.

Maier, Jean L. *Le Baptistère de Naples et ses mosaïques: Étude historique et iconographique*. Fribourg: Éditions universitaires, 1964.

Napoli, Mario. "Topografia e archeologia." *Storia di Napoli* 1:373–508.

Vitolo, Giovanni. *Le città campane fra tarda antichità e alto medioevo*. Salerno: Laveglia, 2005.

## The Ducal Period

Cilento, Nicola. "La chiesa di Napoli nell'alto medioevo." *Storia di Napoli* 2.2:641–736.

—. *Civiltà napoletana del medioevo nel secolo VI–XII*. Naples: Edizioni scientifiche italiane, 1969.

Colletta, T. *Napoli città portuale e mercantile: La città bassa, il porto e il mercato dall'VIII al XVII secolo*. Rome: Kappa, 2006.

Feniello, Amadeo. *Napoli nel medioevo*. Vol. 2. Lecce: Congedo, 2009.

Kelly, Thomas Forrest. *The Exultet in Southern Italy*. New York: Oxford University Press, 1996.

Kreutz, Barbara M. *Before the Normans: Southern Italy in the Ninth and Tenth Centuries*. Philadelphia: University of Pennsylvania Press, 1992.

Rotili, Mario. *L'arte a Napoli dal VI al XIII secolo*. Rome: Unione accademica nazionale, 1978.

Venditti, Arnaldo. "L'architettura dell'alto medioevo." *Storia di Napoli* 2.2:773–876.

## The Normans

Capasso, Bartolommeo. "La Vicaria Vecchia." *Archivio storico per le provincie napoletane* 15 (1889): 97–139, 685–749; 16 (1890): 388–433, 583–635.

Fuiano, Michele. "Napoli normanna e sveva." *Storia di Napoli* 2.1:409–518.

—. *Napoli nel medioevo: Secoli XI–XIII*. Biblioteca napoletana 8. Naples: Libreria scientifica, 1972.

Glass, Dorothy F. "Sicily and Campania: The Twelfth Century Renaissance." *ACTA* 2 (1975): 131–46.

—. *Romanesque Sculpture in Campania*. College Park, PA: The Pennsylvania State University Press, 1991.

Lavarra, C. *Mezzogiorno normanno: Potere, spazio urbano, ritualità*. Lecce: Congedo, 2005.

Loud, Graham A., and A. Metcalfe, eds. *The Society of Norman Italy*. The Medieval Mediterranean 38. Leiden: Brill, 2002.

Musca, Giosuè., ed. *Le eredità normanno–sveve nell'età angioina: Persistenze e mutamenti nel Mezzogiorno*. Atti delle quindicesime giornate normanno–sveve, Bari, 22-25 ottobre 2002. Bari: Dedalo, 2004.

Tronzo, William. *The Cultures of His Kingdom: Roger II and the Cappella Palatina in Palermo*. Princeton: Princeton University Press 1997.

## The Hohenstaufen

Abulafia, David. *Frederick II: A Medieval Emperor*. New York: Oxford University Press, 1988.

—. "The Kingdom of Sicily under Hohenstaufen and Angevin Rule." *New Cambridge Medieval History*. Vol. 5, c.1198–c.1300. David Abulafia, ed. Cambridge: Cambridge University Press, 1999, 497–524.

—. *Italy in the Central Middle Ages, 1000–1300*. Oxford: Oxford University Press, 2004.

Napoli, Mario. "La città." *Storia di Napoli* 2.2:737-72.

Rotili, Mario. "Arti figurative e arti minori." *Storia di Napoli* 2.2:877–986.

Tronzo, William, ed. *Intellectual Life at the Court of Frederick II Hohenstaufen*. Washington, DC: National Gallery of Art, 1994.

Vitolo, Giovanni. "L'età svevo-angioina." In Carratelli, 87–144.

## The Angevins

Abbate, Francesco. *Storia dell'arte nell'Italia meridionale: Il Sud angioino e aragonese*. Rome: Donzelli Editore, 1998.

Abulafia, David. *The Western Mediterranean Kingdoms 1200–1500: The Struggle for Dominion*. London: Longman, 1997, 57–171.

Aceto, Francesco. "Per l'attività di Tino di Camaino a Napoli: Le tombe di Giovanni di Capua e di Orso Minutolo." In *Scritti in ricordo di Giovanni Previtali*. *Prospettiva* 53–56 (1989): 134–42.

—. "Tino di Camaino a Napoli: Una proposta per il sepolcro di Caterina d'Austria e altri fatti angioini." *Dialoghi di storia del'arte* 1 (1995): 10–27.

—. "Un'opera 'ritrovata' di Pacio Bertini: Il sepolcro di Sancia di Maiorca in Santa Croce a Napoli e la questione dell'"usus pauper'." *Prospettiva* 100 (2000): 27–35.

—. "La sculpture de Charles Ier d'Anjou à la mort de Jeanne Ire (1266–1382)." In *L'Europe des Anjou: Aventure des princes angevins du XIIIe au XVe siècle.* Hugues Cornière, ed. Paris: Somogy Ed. d'Art, 2001, 75-87.

—. "Tino di Camaino nel duomo di Napoli." In Romano and Bock, *Il duomo,* 148–55.

—. "Le memorie angioine in San Lorenzo Maggiore." In Romano and Bock, *San Lorenzo e San Domenico,* 67–94.

—. "'Status' e immagine nella scultura funeraria del Trecento a Napoli: Le sepolture dei nobili." In Arturo Carlo Quintavalle, ed. *Medioevo: Immagini e ideologie.* Milan: Electa, 2005, 597–607.

Alabiso, Annachiara, Mario De Cunzo, Daniela Giampaola, Adele Pezzullo, eds. *Il monastero di Santa Chiara.* Naples: Electa, 1995.

Ambrasi, Domenico. "La vita religiosa." *Storia di Napoli* 3:437–574.

Berger-Dittscheid, Cornelia. "S. Lorenzo Maggiore in Neapel: Das gotische 'Ideal'-Projekt Karls I. und seine 'franziskanischen' Modifikationen." In Christoph Andreas, Maraike Bückling, Roland Dorn, eds. *Festschrift für Hartmut Biermann.* Weinheim: Acta humaniora, 1990, 41–64.

Beyer, Andreas. "Napoli." In Francesco Paolo Fiore, ed. *Storia dell'architettura italiana: Il Quattrocento.* Milan: Electa, 1998, 434–59.

Bock, Nicolas. *Antonio Baboccio: Abt, Maler, Bildhauer, Goldschmied und Architekt. Kunst und Kultur am Hofe der Anjou-Durazzo (1380-1420).* Munich: Dt. Kunstverlag, 2001.

—. "I re, i vescovi e la cattedrale: Sepolture e costruzione architettonica." In Romano and Bock, *Il duomo,* 132–47.

Bologna, Ferdinando. *I pittori alla corte angioina di Napoli, 1266–1414, e un riesame dell'arte nell'età fridericiana.* Saggi e studi di storia dell'arte 2. Rome: Ugo Bozzi, 1969.

Bruzelius, Caroline. "Hearing is Believing: Clarissan Architecture, ca. 1213–1340." *Gesta* 31.2 (1992): 83–91.

—. "Il coro di S. Lorenzo Maggiore e la ricezione dell'arte gotica nella Napoli angioina." In Valentino Pace and Martina Bagnoli, eds. *Il Gotico europeo in Italia.* Naples: Electa, 1994, 265–77.

—. "Queen Sancia of Mallorca and the Convent Church of Sta. Chiara in Naples." *Memoirs of the American Academy in Rome* 40. Ann Arbor: University of Michigan Press 1995, 69–100.

—. "Charles I, Charles II, and the Development of an Angevin Style in the Kingdom of Sicily." In *L'État angevin,* 99–114.

—. "*Il Gran Rifiuto*: French Gothic in Central and Southern Italy." In *Architecture and Language: Constructing Identity in European Architecture, c.1000–c.1650*. Georgia Clarke and Paul Crossley, eds. Cambridge: Cambridge University Press, 2000, 36–45.

—. *The Stones of Naples: Church Building in Angevin Italy, 1266–1343*. New Haven: Yale University Press, 2004.

—. "Ipotesi e proposte sulla costruzione del duomo di Napoli." In Romano and Bock, *Il duomo*, 119–31.

—. "Workers and Builders in the Angevin Kingdom." In David H. Friedman, Julian Gardner, and Margaret Haines, eds. *Arnolfo's Moment: Acts of an International Conference (Florence, Villa I Tatti, May 26–27, 2005)*. Florence: Olschki, 2009, 107–21.

Causa, Raffaello. *L'arte nella Certosa di San Martino a Napoli*. Cava dei Tirreni: Di Mauro, 1973.

Cundari, Cesare, ed. *Il complesso di Monteoliveto a Napoli: Analisi, rilievi, documenti, informatizzazione degli archivi*. Rome: Gangemi, 1999.

Dell'Aja, Gaudenzio. *Il restauro della basilica di S. Chiara in Napoli*. Naples: Giannini, 1980.

Di Meglio, Rosalba. *Il Convento Francescano di S. Lorenzo di Napoli: Regesti dei documenti dei secoli xiii-xv*. Documenti per la storia degli ordini mendicanti nel Mezzogiorno 2. Salerno: Carlone, 2003.

Elliott, Janis, and Cordelia Warr, eds. *The Church of Santa Maria Donna Regina: Art, Iconography, and Patronage in Fourteenth-Century Naples*. Burlington, VT: Ashgate, 2004.

Enderlein, Lorenz. "Zur Entstehung der Ludwigstafel des Simone Martini in Neapel." *Römisches Jahrbuch für Kunstgeschichte* 33 (1995): 136–49.

—. "Die Grundungsgeschichte der 'Incoronata' in Neapel." *Römisches Jahrbuch der Bibliotheca Hertziana* 31 (1996): 15–45.

—. *Die Grablegen des Hauses Anjou in Unteritalien: Totenkult und Monumente 1266–1343*. Römische Studien der Bibliotheca Hertziana, Bd. 12. Worms-am-Rhein: Wernersche Verlagsgesellschaft, 1997.

Estve, Gabriel Alomar. "Iconografia y heraldica de Sancha de Mallorca, reina de Nápoles." *Boletín de la Sociedad arqueólogica luliana* 35 (1976): 5–36.

*L'État angevin: Pouvoir, culture et société entre XIIIe et XIVe siècle. Actes du colloque international organisé par l'American Academy in Rome (Rome–Naples, 7–11 novembre 1995)*. Collection de l'École Française de Rome 245; Nuovi studi storici 45. Rome: École Française de Rome & ISIME, 1998.

Filangieri di Candida, Antonio. *La chiesa e il monastero di San Giovanni a Carbonara*. Riccardo Filangieri, ed. Naples: Lubrano, 1924.

Frede, Carlo de. "Da Carlo I d'Angio a Giovanni I (1263–1382)." *Storia di Napoli* 3:1–334.

—. "Nel Regno di Roberto d'Angio." *Storia di Napoli* 3:157–224.

Freigang, Christian. "Kathedralen als Mendikantenkirchen: Zur politischen Ikonographie der Sakralarchitektur unter Karl I., Karl II. und Robert dem Weisen." In *Medien der Macht: Kunst zur Zeit der Anjous in Italien*. Tanja Michalsky, ed. Berlin: Reimer, 2001, 33–60.

Gaglione, Mario. "La basilica ed il monastero doppio di S. Chiara a Napoli in studi recenti." *Archivio per la storia della donna* 4 (2007): 127–209.

Gallino, Tomaso M., and Mario Zampino. *Il complesso monumentale di Santa Chiara in Napoli*. Naples: Pontificio Istituto Superiore di Scienze e Lettere S. Chiara dei Frati Minori, 1963.

Gardner, Julian. "Saint Louis of Toulouse, Robert of Anjou, and Simone Martini." *Zeitschrift für Kunstgeschichte* 39 (1976): 12–33.

—. "A Princess among Prelates: A 14th-Century Neapolitan Tomb and Some Northern Relations." *Römisches Jahrbuch für Kunstgeschichte* 23/24 (1988): 31–60.

—. "Santa Maria Donna Regina in Its European Context." In Elliott and Warr, 195–201.

Genovese, Rosa Anna. *La chiesa trecentesca di Donnaregina*. Naples: Edizioni Scientifiche Italiane, 1993.

Guidarelli, Gianmario. "La costruzione del Duomo di Napoli e l'invenzione di una falsa tradizione." In *Storia e narrazione: Retorica, memoria, immagini*. Gianmario Guidarelli and Carmelo G. Malacrino, eds. Milan: Mondadori, 2005, 35–44.

—. "La ricostruzione angioina della cattedrale di Napoli, 1294–1333." In *I luoghi del sacro: Il sacro e la città fra medioevo ed età moderna*. Fabrizio Ricciardelli, ed. Florence: Mauro Pagliai Editore, 2008, 187–206.

Heullant-Donat, Isabelle. "Quelques réflexions autour de la cour angevine comme milieu culturel au XIVe siècle." In *L'État angevin*, 173–91.

Leone de Castris, Pierluigi. "Napoli, capitale del Mezzogiorno angioino: L'arte e la corte." In Musca, *La cultura*, 127–99.

—. *Arte di corte nella Napoli angioina*. Florence: Cantini, 1986.

—., ed. *Castel Nuovo: Il Museo Civico*. Naples: E. de Rosa, 1990.

Morisani, Ottavio. *Pittura del Trecento in Napoli*. Naples: Libreria scientifica editrice, 1947.

—. "L'Arte di Napoli nell'età angioina." *Storia di Napoli* 3:575–664.

—. "Aspetti della regalità in tre monumenti angioini." *Cronache di archeologia e storia dell'arte* 9 (1970): 88–122.

—. "Monumenti trecenteschi dei Angioini a Napoli." In *Gli Angioini di Napoli e Ungheria: Atti del colloquio italo–ungherese*. Rome: Accademia Nazionale dei Lincei, 1972, 159–73.

Musca, Giosuè, Francesco Tateo, Enrico Annoscia, and Pierluigi Leone de Castris, eds. *La Cultura angioina: Civiltà del Mezzogiorno*. Milan: Silvano Editoriale, 1985.

Musto, Ronald G. "Queen Sancia of Naples (1286–1345) and the Spiritual Franciscans." In *Women of the Medieval World*. Julius Kirshner and Suzanne Wemple, eds. Oxford: Basil Blackwell, 1985, 179–214.

—. "Franciscan Joachimism at the Court of Naples, 1305–1345: A New Appraisal." *Archivum Franciscanum Historicum* 90.3–4 (1997): 1–86.

Pade, Marianne, Hannemarie Ragn Jensen, and Lene Waage Petersen, eds. *Avignon and Naples: Italy in France–France in Italy in the Fourteenth Century*. Rome: L'Erma di Bretschneider, 1997.

Palmieri, Stefano. "Il Castelnuovo di Napoli, reggia e fortezza angioina." *Atti della Accademia Pontiniana* n.s. 47 (1999): 501–19.

Pane, Giulio. *La Tavola Strozzi tra Napoli e Firenze: Un'immagine della città nel Quattrocento*. Naples: Grimaldi & C. Editori, 2009.

Rotili, Mario. *Miniatura francese a Napoli*. Benevento: Museo del Sannio, 1968.

Sabatini, Francesco. *Napoli angioìna: Cultura e società*. Naples: Edizioni scientifiche italiane, 1975.

Venditti, Arnaldo. "Urbanistica e architettura angioina." *Storia di Napoli* 3:665–888.

Vitolo, Giovanni. "Il regno angioino." In *Storia del Mezzogiorno* 4.1. *Il Regno dagli Angioini ai Borboni*. Giuseppe Galasso and R. Romeo, eds. Rome: Edizioni del Sole–Rizzoli, 1986; Editalia, 1994, 9–86.

—. "L'età svevo–angioina." In Carratelli, 87–144.

—., and Rosalba Di Meglio. *Napoli angioino–aragonese: Confraternite, ospedali, dinamiche politico–sociali*. Salerno: Carlone, 2003.

Vitolo, Paola. *La chiesa della regina: L'Incoronata di Napoli, Giovanni I d'Angiò e Roberto di Oderisio*. Rome: Viella, 2008.

Warr, Cordelia, and Janis Elliott, eds. *Art and Architecture in Naples, 1266–1713: New Approaches*. Oxford: Wiley-Blackwell, 2010.

■

# ONLINE RESOURCES

**Online Chapters: Contents**
*Medieval Naples: A Documentary History, 400–1400*
http://www.italicapress.com/index286.html

**Interactive Map**
http://www.italicapress.com/index287.html

**Online Bibliography**
http://www.italicapress.com/index346.html

**Documents**

    2. Late Roman and Byzantine Naples
    http://www.italicapress.com/index333.html

    3. Ducal Naples
    http://www.italicapress.com/index335.html

    4. The Normans
    http://www.italicapress.com/index344.html

    5. The Hohenstaufen
    http://www.italicapress.com/index309.html

    6. The Angevins
    http://www.italicapress.com/index300.html

## ONLINE RESOURCES

### Image Galleries

The URL for each site is derived from taking the Italica Press Gallery URL (http://gallery.mac.com/rgmusto ) and adding the specific site number. Thus, for example, the URL for the Castel Capuano web gallery is: http://gallery.mac.com/rgmusto#100255. Or readers can simply go to the Italica Press Gallery home page and click into the appropriate site gallery. The numbers of images in each gallery is the total uploaded as of December 29, 2010.

| Site | Gallery # | Images |
|---|---|---|
| Castel Capuano | 100255 | 10 |
| Castel dell'Ovo | 100036 | 33 |
| Castel Nuovo | 100044 | 26 |
| Castel Sant'Elmo (Belforte) | 100243 | 8 |
| Catacomb of San Gennaro | 100331 | 11 |
| Certosa di San Martino | 100177 | 5 |
| Duomo (Cathedral) | 100059 | 29 |
| San Domenico Maggiore | 100116 | 25 |
| San Giorgio Maggiore | 100410 | 12 |
| San Giovanni a Carbonara | 100146 | 26 |
| San Giovanni a Mare | 100099 | 23 |
| San Giovanni a Pappacoda | 100138 | 9 |
| San Giovanni in Fonte (Baptistery) | 100398 | 14 |
| San Lorenzo Maggiore | 100073 | 19 |
| San Paolo Maggiore | 100336 | 10 |
| San Pietro a Maiella | 100075 | 13 |
| Sant'Eligio | 100069 | 14 |
| Sta. Chiara | 100120 | 44 |
| Sta. Chiara, Campanile | 100153 | 10 |
| Sta. Maria Donnaregina | 100052 | 26 |
| Sta. Maria Incoronata | 100122 | 33 |
| Sta. Maria la Nova | 100232 | 26 |
| Sta. Maria Maggiore (Pietrasanta) | 100091 | 19 |
| Sta. Restituta | 100423 | 11 |
| **Total images as of 12/29/2010** | | **456** |

■

# MEDIEVAL NAPLES: ARCHITECTURAL & URBAN HISTORY

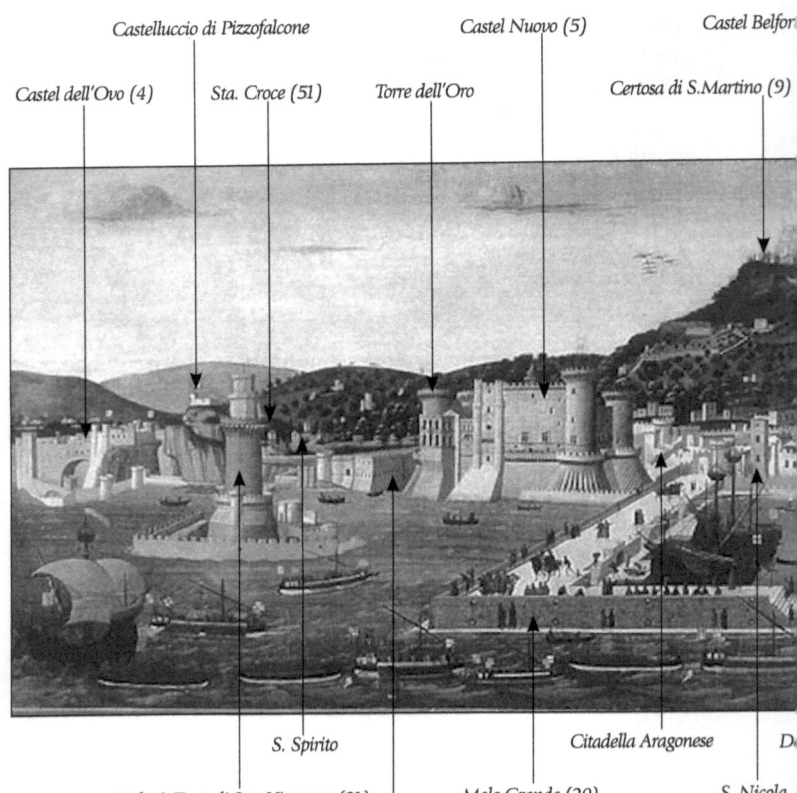

## THE TAVOLA STROZZI

The *Tavola Strozzi* is a panoramic panel painting of the bay, city and environs of Naples. It was discovered by Corrado Ricci in 1901 in the Palazzo Strozzi in Florence. The scholarly consensus now identifies it as the celebration of the Aragonese defeat of Jean d'Anjou on 7 July 1465 at the naval battle of Ischia. The painting is tempera on wood, 82 x 245 cm., now in the Museo di San Martino. It was most likely a cassone panel, perhaps the headboard of a bed designed by Benedetto da Maiano. It has been convincingly dated now to between 1465 and 1478, most likely to 1472/73. The crispness of its detail provides a remarkably accurate visual source for the Aragonese and medieval city.

## APPENDICES

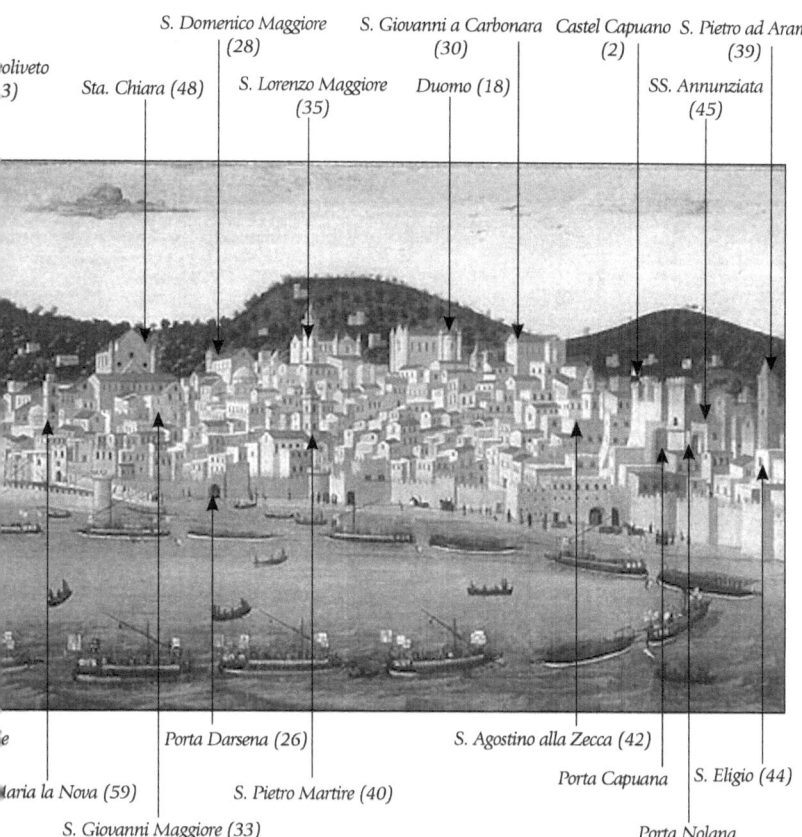

The perspective point of the *Tavola* is either from a ship off the Molo Grande or from the tower on the Molo itself, as argued in a recent analysis by Roberto Taito (http://www.tavolastrozzi.it/studio.htm). Scholarly consensus had settled on Francesco Rosselli or Francesco Pagano as its painter, but this has been cast into doubt by Pane (2009), 94–119, 141–67, who cites the lack of documentary evidence and attributes it to an unknown Tuscan painter, perhaps in Florence or Siena (141), who executed it from perspective drawings carried out in Naples. The image has been discussed and analyzed at length. See, for example, Di Mauro (1992); De Seta (1997), 11–53; and most recently in Pane (2009).

Labels are to identifiable sites and many are also keyed to the map below, pp. 128–29.

## MEDIEVAL NAPLES: ARCHITECTURAL & URBAN HISTORY

# APPENDICES

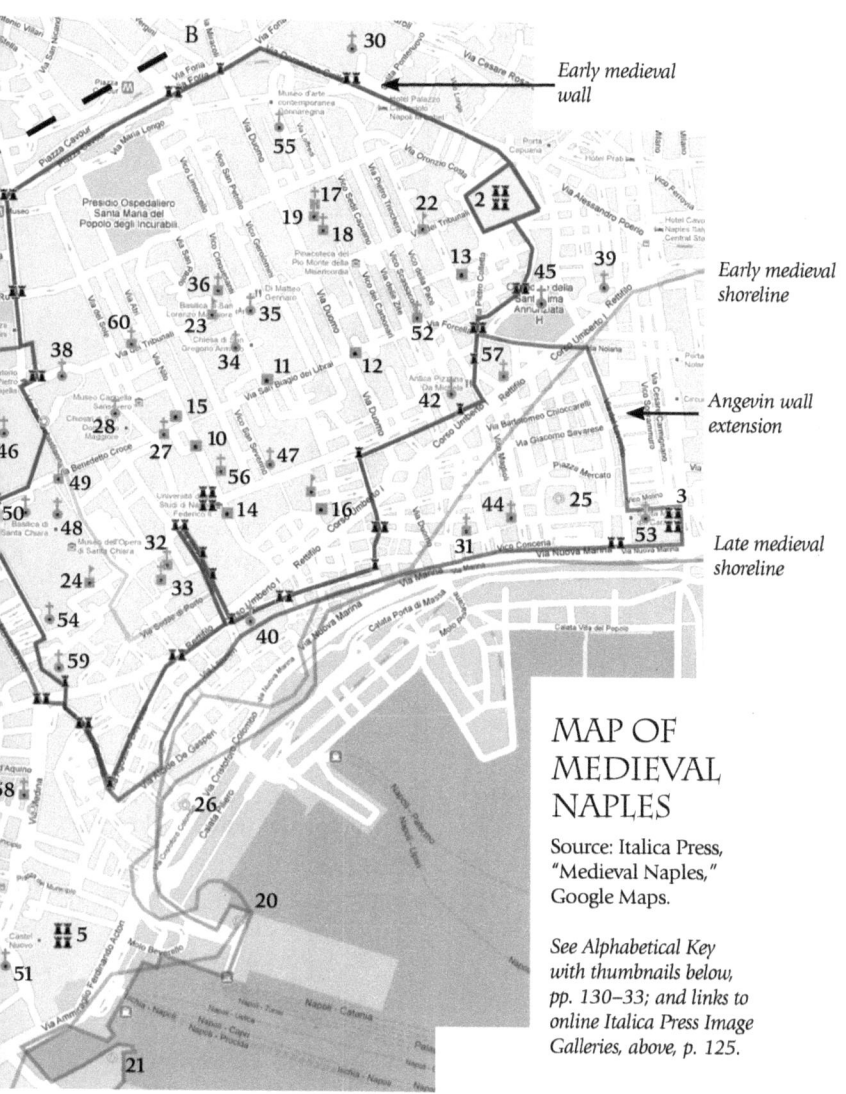

Early medieval wall

Early medieval shoreline

Angevin wall extension

Late medieval shoreline

## MAP OF MEDIEVAL NAPLES

Source: Italica Press, "Medieval Naples," Google Maps.

*See Alphabetical Key with thumbnails below, pp. 130–33; and links to online Italica Press Image Galleries, above, p. 125.*

# MEDIEVAL NAPLES: ARCHITECTURAL & URBAN HISTORY

## ALPHABETICAL KEY TO MAP

 1. Castel Belforte

 9. Certosa di S. Martino

 2. Castel Capuano

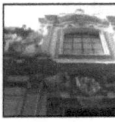 10. Diaconia of S. Andrea ad Nilum

 3. Castel del Carmine

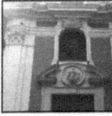 11. Diaconia of S. Gennaro all'Olmo

 4. Castel dell'Ovo

 12. Diaconia of S. Giorgio Maggiore

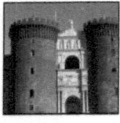 5. Castel Nuovo

 13. Diaconia of S. Pietro

 6. Catacomb of S. Gaudioso

 14. Diaconia of SS. Giovanni e Paolo

 7. Catacomb of S. Gennaro

 15. Diaconia of Sta. Maria ad Presepem

 8. Catacomb of S. Severo

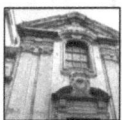 16. Diaconia of Sta. Maria in Cosmedin (in Portanova)

# APPENDICES

 17. Duomo: Baptistery (San Giovanni in Fonte)

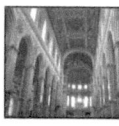 18. Duomo: Cathedral of Sta. Maria Assunta

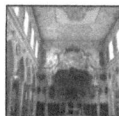 19. Duomo: Sta. Restituta

 20. Molo Grande

 21. Torre & Molo San Vincenzo

 22. Palazzo of Gianni Caracciolo

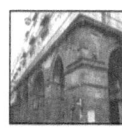 23. Palace of Philip of Taranto

 24. Palazzo Penna

 25. Piazza del Mercato

 26. Portus de Arcina

 27. S. Angelo a Nilo

 28. S. Domenico Maggiore

 29. S. Gennaro extra Moenia

 30. S. Giovanni a Carbonara

 31. S. Giovanni a Mare

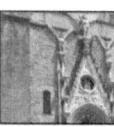 32. S. Giovanni a Pappacoda

 33. S. Giovanni Maggiore

 41. S. Trinità al Palazzo

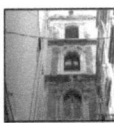 34. S. Gregorio Armeno

 42. Sant'Agostino alla Zecca

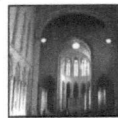 35. S. Lorenzo Maggiore

 43. Sant' Anna dei Lombardi (Monteoliveto)

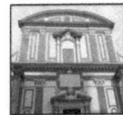 36. S. Paolo Maggiore

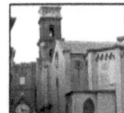 44. Sant'Eligio

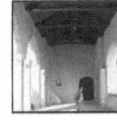 37. S. Pietro a Castello

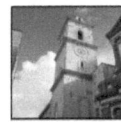 45. SS. Annunziata

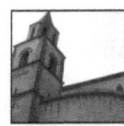 38. S. Pietro a Maiella

 46. SS. Sergio, Bacco e Sebastiano

 39. S. Pietro ad Aram

 47. SS. Severino e Sossio

 40. S. Pietro Martire

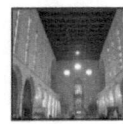 48. Sta. Chiara

# APPENDICES

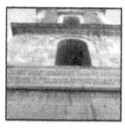 49. Sta. Chiara: Campanile

 57. Sta. Maria Egiziaca

 50. Sta. Chiara: Friars' Church

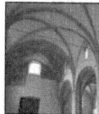 58. Sta. Maria Incoronata

 51. Sta. Croce

 59. Sta. Maria la Nova

 52. Sta. Maria in Piazza

 60. Sta. Maria Maggiore (Pietrasanta)

 53. Sta. Maria del Carmine

 54. Sta. Maria Donnalbina

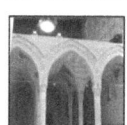 55. Sta. Maria Donnaregina

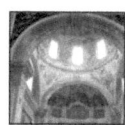 56. Sta. Maria Donnaromita

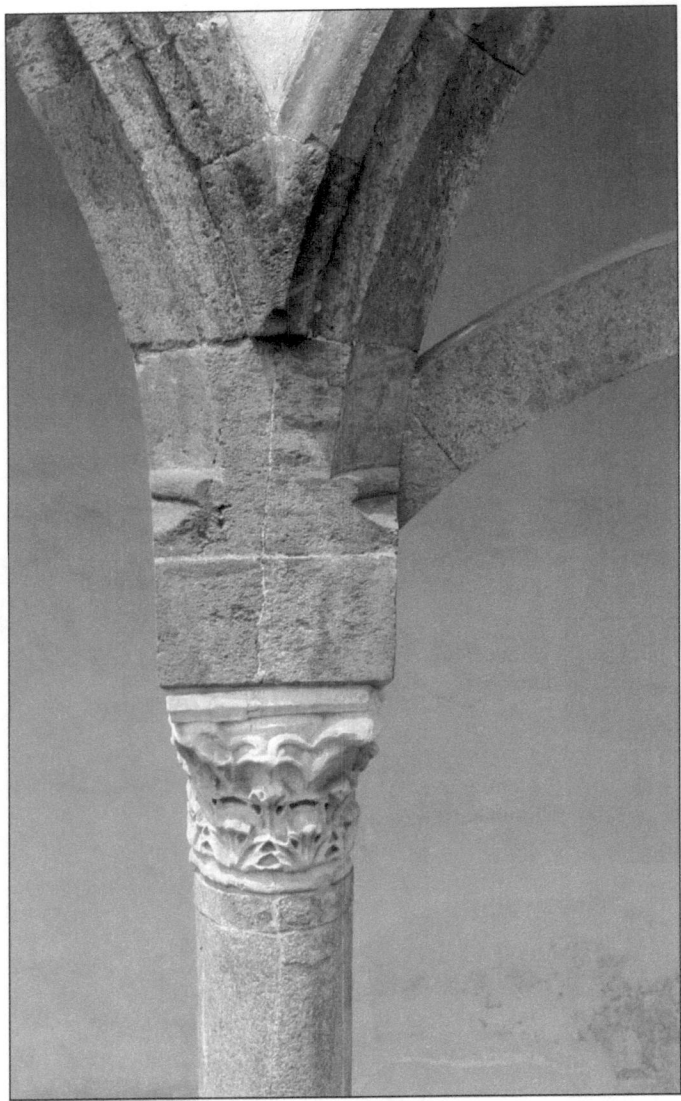

Fig. 79. Sta. Maria Incoronata, loggia, springing of arches.

# INDEX

*Unless otherwise indicated, all main headings such as churches, piazze, vie, refer to Naples. Page references to figures are in parentheses in **bold italic: (1)**.*

## A

Acciaiuoli family 87
Aceto, Francesco 81
Achelis, Hans 23
agora. *See* forum.
Aix-en-Provence, Notre-Dame-de-Nazareth 92; St.-Jean-de-Malte 92
Alfonso of Aragon 64, 112
Altomonte, Sta. Maria della Consolazione 111–12
Amalfi 55, 62
  Chiostro del Paradiso 31
Angevins 54, 55, 86; patronage 62–112; reconfiguration of city 98–112; of Hungary 112
Anthemius. *See* dukes.
Apostles. *See* saints.
Apulia 63
aqueducts 86
Aragon 64, 100; Aragonese 49, 54, 66, 70, 80, 94, 112, 126
archaeology 14; excavations 9, 11, 12, 16, 28, 32
archives xii; ALIM xii; archival research 57; Simancas 66, 67
Arsenal 54, 86
Arthur, Paul 3, 22, 42
Asia Minor 11–12
Assisi, San Damiano 80
Augustinians 86, 106
Augustus, emperor 11
Aversa 90
Avignon 110, 111

## B

Baboccio, Antonio 109, 112
baptistery. *See* churches: baptistery.
Bari, church of San Nicola 87
Barletta 98
Bartolomeo di Capua 79, 106
Basilians 51, 86
Basilicata 63
Baths of Titus 10
Bay of Naples 1, *(1)*, 41,
Beatrice of Provence, queen 92
Belisarius 2
Benedictines 51, 58, 67, 98
Benevento 16, 20, 23
Benjamin, Walter 10
Bern (Burgerbibliothek 120 II) 4
Bertini, Giovanni and Pacio 83, 104
Bible
  Apocalypse 35, 37, 102
  Ezekiel 35, 37
  Miraculous Draught of Fishes 35
  Old Testament 111
  Samaritan Woman at the Well 35, 38
  Three Women (Marys) at the Tomb 35, 38
  *Traditio legis* 35, *(35)*, 38
  Walking on Water 35, 39
bishops & archbishops 16, 18, 19, 20, 21, 22, 30, 40, 41
  Agrippinus 20
  Aiglerius 65, 93
  Athanasius I 4, 21
  Filippo Minutolo 88, 93
  Giovanni di Capua 78
  John (Giovanni) I 16, 17, 22
  John II 43

John IV 20, 32
Paul II 21
Peter of Sorrento 58, 59, 60
Pomponius 43
Severus 23, 33, 43
Stephen I 31
Vincent 29, 31, 43
Blanche of Castile 66
Boccaccio, Giovanni 71
Bologna, church of San Francesco 74
Bologna, Ferdinando 75
Boniface VIII, pope 102
bronze horse 59
Byzantine culture 55

C
Calabria 82, 111–12
Campania 56; architecture 29, 45, 55, 60, 61, 62, 89–91, 106; cultural elites 62; learning 58
Campo Moricino 51, 57–58, 65. *See also* piazze: del Mercato.
Capodimonte 13, 16, 21, 22
Capua 58, 59, 62, 106; Roman arch 62
Caracalla, emperor 10
Caracciolo, Sergianni 108
*cardo–decumanus*. *See* topography and plan.
Carinola 56
Carmelites 65, 66, 86
Carthage 18, 27
Carthusians 106
Caserta Vecchia 45, 60–61, *(61)*, 90; Andrea of Capua, bishop 60
castles
  Castel Belforte 84, 105, 125, *(126)*, *(130)*

Castel Capuano 4, 59, 64, 85, 125, *(130)*
Castel dell'Ovo *(xv)*, *(9)*, 9, 86, 125, *(126)*, *(130)*
Castel Nuovo 52, *(53)*, 54, 58, 64, 66, 84, 85, 94, 98, 102, 103–4, 105, 111, 112, *(113)*, 125, *(126)*, *(130)*
Castel Sant'Erasmo. *See* Castel Belforte.
Castle Sant'Elmo. *See* Castel Belforte.
Castrum Lucullanum ix, *(9)*
catacombs ix, 12–24
  cubicula 20
  hypogea 14, 15
  loculi 15, 17, 20
  Roman 13, 20
  San Fortunato 13, 23
  San Gaudioso 13, 23, 24, 39, *(130)*
  San Gennaro *(13–19)*, 13–24, 32, 39, 125, *(130)*
    arcosolium of Quodvultdeus 18
    "cripta dei vescovi" 17, 32, 40
    Ilaritas and Theotecnus 19, 20
    Nonnosa 19, 20
  San Severo 13, 23, 24, *(130)*
  Sant'Eusebio 13, 23
  Sta. Maria della Sanità. *See* catacombs: San Gaudioso.
Catalonia 100
cathedral. *See* churches: cathedral.
Catherine of Austria 77; tomb 77–78, 82
Cava de' Tirreni 58
Cavallini, Pietro 84, 95–96

136

# INDEX

Celestines 98
Celestine V, pope 98
Charles I, king 51, 52, 58, 63–68, 84, 87, 92
Charles II, king 66, 73, 75, 80, 84, 86–88, 92, 94, 95, 98, 100, 101; building projects 86; patronage 87–88
Charles Martel, of Anjou 92, 102
Charles of Calabria 77, 80, 83, 104, 105
Chierici, Bruno 52
*Chi-Rho* 35–36
Christianity, in Naples 12
*Chronicon episcoporum s. napolitanae ecclesiae* 16, 21, 31, 32
churches
  baptistery (San Giovanni in Fonte) ix, xi, 26, 29, 31–41, *(33–36)*, *(38)*, *(40)*, 60, 125, *(131)*
  cathedral (duomo, Sta. Maria Assunta, San Gennaro) x, xi, 20, 24–32, *(25)*, *(26)*, *(28)*, 49, 50, 55, 59, *(60)*, 65, 67, 68, 75, 78, 79, 83, 87–94, *(89)*, *(90)*, 98, 104, 109, 125, *(127)*, *(131)*; D'Ormont chapel 89; episcopal complex 31, 32, 59; Minutolo Chapel 75, 83–84, 88–89, 93–94 *(93–94)*; Stefania 24, 31–32
  Montevergine. *See* Sta. Maria del Montevergine.
  San Domenico Maggiore 55, 80–83, *(81)*, *(82)*, 92, 95, 96, 98, 99, 106, 125, *(127)*, *(131)*; Brancaccio Chapel 83, 96

San Gennaro. *See* churches: duomo.
San Giorgio Maggiore *(xvi)*, 43, 91, 125, *(130)*
San Giovanni a Carbonara 53, 55, 125, *(131)*; Caracciolo del Sole Chapel 108; tomb of King Ladislao 106–8, *(107)*, *(127)*
San Giovanni a Mare 56–57, *(57)*, 65–66, 125, *(131)*
San Giovanni a Pappacoda *(108)*, 108–9, 125, *(131)*
San Giovanni in Fonte. *See* churches: baptistery.
San Giovanni Maggiore 43, *(127)*, *(132)*
San Gregorio Armeno 74, *(132)*
San Lorenzo Maggiore 8, 9, *(42)*, 43, 45, 49, 50, 52, 55, 58, 65, 67, 70–80, *(72–73)*, *(76–79)*, 81, 83, 93, 95, 99, 106, 125, *(127)*, *(132)*; Aldomoresco Tomb 109
San Martino 55, 105
San Paolo Maggiore 7, 8, 44, *(44)*, 125, *(132)*
San Pietro a Castello 95, *(132)*
San Pietro a Maiella 98, *(99)*, 125, *(132)*
San Pietro Martire 54, 95, 99, *(127)*, *(132)*
Sant'Agostino alla Zecca 52, 55, 99, *(127)*, *(132)*
Sant'Angelo a Morfisa 58
Sant'Aniello a Caponapoli 31
Sant'Efremo Vecchio 13, 23
Sant'Eligio 51, 53, 56, 65–69, *(68–70)*, 74, 78, 125, *(127)*, *(132)*

Sta. Barbara 64, 94, 103
Sta. Chiara *(ii)*, *(48)*, 55, 66, 83, *(83)*, 84, 99, 100–104, *(101)*, *(103)*, 109, 125, *(127)*, *(132)*; campanile 52 *(133)*
Sta. Croce di Palazzo 54, 105, *(133)*
Sta. Maria Assunta. *See* churches: cathedral.
Sta. Maria del Carmine 52, 65, 66, *(67)*, 99, *(133)*
Sta. Maria del Montevergine 75, 83, 86, 106
Sta. Maria della Sanità 13, 23
Sta. Maria del Principio 94
Sta. Maria Donnaregina 52, 82, 83, 84, *(85)*, 95, *(96–97)*, 99, *(114)*, 125, *(133)*
Sta. Maria Incoronata 54, *(109–111)*, 111, 125, *(133–134)*
Sta. Maria la Nova 52, 66, 70, *(71)*, 99, 125, *(127)*, *(133)*
Sta. Maria Maggiore (Pietrasanta) 44–46, *(45)*, *(47)*, 61, 125, *(133)*
Sta. Restituta ix, 18, 20, 24–34, *(26–27)*, *(38)*, 50, 59, 88–89, 92–93, 125, *(131)*
Stefania. *See* churches: cathedral, Stefania.
Cistercians 67
city plan. *See* topography and plan.
Clarissans (Clares) 83, 95, 102
Clemenza of Anjou 92
climate 1
confraternities, patronage ix, 51, 65, 66, 100
Conradin, king 65

Constans, emperor 2
Constantine the Great, emperor 24, 25, 37, 59–60, 93
Constantinople 19, 25; Hagia Sophia 25; Holy Apostles 25
convents 51, 52, 54, 58, 59, 66, 70, 74, 83, 95, 98, 100, 102
Cuma 2

D
*decumanus*. *See* topography and plan.
D'Engenio Caracciolo, Cesare 79
*diaconiae* x
di Capua family 78
Di Meglio, Rosalba 74
Diocletian, emperor 27
d'Olanda, Francesco 8
Dominicans 58, 59, 80, 86, 87, 95
*domus* 9, 28
D'Ormont, Umberto 93
Duca di Noia plan *(50)*, *(51)*, *(53)*, *(71)*
duchy ix, xi, 2, 43
dukes of Naples, Anthemius 43; Sergius I 2; Stephen II 2
Duomo. *See* churches: Duomo.
Dura Europos 39

E
earthquakes 80, of 1343 71; of 1349 68; of 1456 60
Elizabeth of Hungary, queen 84
Esclaramonde de Foix 102
Eucharist, vision 102
*extra moenia* x, 9. *See also* walls.

F
Fasola, Umberto 14, 16, 17, 18, 19, 21

## INDEX

Florence, artistic influence 83, 108
foreign communities, French 65, 73, 87; Provençal 65, 87
fortifications 58, 63, 84. *See also* castles, walls.
forum x, 7, *(8)*
France 63, 69, 100; architectural influence xi, 73–74
Franciscans 58, 59, 64, 66, 70, 71, 73, 74, 78, 79, 80, 81, 86, 100, 102, 104; architects 78; Spirituals 100, 102
Fraticelli. *See* Franciscans, Spirituals.
Frederick II, emperor 58, 62, 63, 64
Friars 62. *See also* Augustinians, Dominicans, Franciscans, etc.
Frugoni, Chiara 4

### G

Gaeta 55
Gandolfi, Katia 38
gardens, medieval 54
Gerace 82, 112
Giotto di Bondone 84, 102–3
Giovanna I, queen 104, 110, 111
Giovanna II, queen 107, 112
Giovanni Pipino da Barletta 98
Gothic court style 108
Goths 2, 21, 41
Greeks x; settlement of Pizzofalcone 2, 86
grid plan. *See* topography and plan.
gymnasium 10

### H

Heleudinius 23
Henry VI, emperor 4

Henry VII, emperor 104
Hippodamean grid. *See* grid plan.
hippodrome x
Hohenstaufen 65
Horace 9
hospices 51, 100
hospitals 51, 56, 59, 65, 66, 68, 80, 86, 100, 106; Sant'Angelo a Morfisa 58; Sta. Maria Incoronata 111
houses, ancient 49. *See also* domus.
Hungary 95

### I

Île-de-France 69
*insulae* 9. *See also* topography and plan.
Ischia 27
Islam 55
Isolympic Games 11

### J

Januarius, St. *See* saints, Gennaro.
Joachim of Fiore 100
John of Parma 71
John the Deacon 20

### K

Kingdom of Sicily. *See* Sicily, kingdom of.
Knights Hospitaller 55
Krautheimer, Richard 25

### L

La Chaise Dieu 69
Ladislao, king 107–8, 112
Lagopesole 63
Latium 12

Lello da Orvieto 94
Leonardo da Besozzo 108
Leone de Castris, Pierluigi 30, 31
Lewis of Hungary, king 110
*Liber pontificalis*, Roman 24
Lombards 2, 20, 41, 55
Louis VIII, king of France 66
Louis IX, king of France 64
Louis of Anjou 75
Lucera 98
Lucullus, L. Licinius 9

M

Maier, Jean Louis 34, 36
Malta 10, 18
Marches, the 100
Marcianum 23
Margaret of Durazzo 109
markets, ancient 49; del Carmine 51, 58, 65, 66; macellum at San Lorenzo 8, *(8)*, 43, 50, 71
Marseille 64
martyrs. *See* saints.
Mary of Hungary, queen 82, 83, 95, 104
Mary of Valois, queen 83, 104
Mediterranean xi, 1, 63
Melfi 63
mendicant orders, churches 67, 84, 98; patronage 51, 55, 58, 66, 79
merchant communities, foreign 57; patronage 55, 56, 62, 65
methodological approaches xi–xii
*Metropolitana* xii, 11, 12, 57
   Linea 1 11
   Stazione Duomo 11
   Stazione Municipio 11
   Stazione Toledo 11
   Stazione Università 12

Milan 19, 112
Mileto 82
Minutolo, Enrico 112
Minutolo, Filippo 88, 93
monasteries 49, 50, 51, 53, 58, 74, 86; San Salvatore *(xv)*, *(9)*, 86. *See also* patronage.
Monreale 64
Montano d'Arezzo 75, 83, 93
Montecassino 31, 58, 62
Montpellier 102
mosaics 34–40

N

Narses 2
*Neapolis* 2, 5, 9, 10
Nero, emperor 10
*nobiles* xi
Nola 22, 112; Orsini churches 111; Sta. Maria Iacobi 87
Normans xi, 2, 4, 51, 55, 63, 64, 84, 85, 86
North Africa 10, 17, 18, 29
*nudum theatrum* 8

O

*odeon* 8, *(8)*
Odoacer, king ix
Olympia 11
Orsini family 111
Ostia 9

P

Padula 106
palazzi, medieval 54; Penna 54, *(54)*, *(131)*; of Prince of Taranto 54, *(54)*, *(131)*
*Palaiopolis* 2
Palermo 63, 64, 84
Palestine 24
Paris 74

# INDEX

parishes 57
*Parthenope* 2
Pascentius 24
patronage ix, 33, 62–80
Paulinus of Nola 22–23
*Pericoloso*, bull 102
Perpignan 102
Perrineto da Benevento 108
Peter of Eboli *Liber ad honorem augusti (3)*, 4
Peter of Morrone. *See* Celestine V, pope.
Petrarch, Francesco 71, 102, 103
piazze, Bellini *(5)*, 6; Calenda *(5)*, 6; Cavour 6; del Mercato 58, *(131)*; del Plebiscito 54; Nicola Amore 12; Riario Sforza 59, 60. *See also* markets: del Carmine.
Pietrasanta. *See* churches: Sta. Maria Maggiore.
Pisa 104
Piscicello, Cardinal 60
Pizzofalcone 2
*pomerium* 13
Pompei 9
Poor Clares. *See* Clarissans.
population 41–42; depopulation 50
porosity, of Naples 10. *See also* Benjamin, Walter; topography and plan: porosity.
port x, 6, 11, 12, 50, 51, 55, 57, 58, 65, 66, 86, 102
Porziuncula 80. *See also* Assisi.
Pozzuoli 12, 62
*praetorium* x
Provence 87, 92, 100
Puteoli. *See* Pozzuoli.

Q
Quodvultdeus, bishop of Carthage 18, *(18)*

R
Ravello 72
Ravenna 19, 39; Mausoleum of Galla Placidia 18; Neonian baptistery 39
Raymond Berengar 75
Rayonnant style 69
Regno. *See* Sicily, kingdom of.
religious foundations ix, 49–62
Renaissance, learning centers 59; style 52, 108–9, 112
*Risanamento*. *See* topography and plan: *Risanimento*.
roads 13, 45, 59, 60, 64, 86
Roberto di Oderisio 111
Robert of Anjou, the Wise, king 83, 84, 100–106, 110
Romano, Serena 88
Rome xi, 39, 62–64; ancient xi, 9–10; catacombs 12, 15, 17, 20, 22; early Christian (Constantinian) basilicas x, 24–25, 88, 91; Lateran Baptistery and Basilica 33; Sta. Costanza 39; empire ix; papal xi, 12, 62–64
Romulus Augustulus, emperor ix
Rufolo family 72

S
Sacraments 111
saints
  Apostles 25, 28, 36, 37
  Bruno of Cologne 105
  Catherine of Alexandria 84
  Denis 65
  Eloi 65

Felix 22
Francis of Assisi 79
Gaudioso 18
Gennaro *(17)*; reliquary and remains 17, 20, 87, *(87)*, 92–94
Januarius. *See* saints: Gennaro.
Lawrence 25
Martin 65
martyrs 37
Mary Magdalene 87
Mary, Virgin 75, 86, 94, 108
Matthew 39, *(40)*
Paul 12, 24, 43, 89, 93
Peter 12, 24, 25, 59, 88, 89, 93, 94
Restituta 18, 27, 31, 59, 94
Severus 91
Salerno 55, 62, 109; medical school 58; prince of 80
Samnites 2
Sancia of Majorca, queen 54, 92, 100–102, 104–5, *(105)*, 110
San Giovanni in Fonte. *See* churches: baptistery.
San Martino Museum 54, 126
Sanseverino, Tommaso di 106
Sant'Angelo in Formis 31
Sant'Efremo Vecchio. *See* catacombs: Sant'Eusebio.
*seggi* 51, 54; di Montagna 71, 74; Tribunali 71
Septimius Severus, emperor 10
Sergian dynasty 2. *See also* dukes.
Seroux d'Agincourt 105
Sessa Aurunca 56, 61, *(63)*, 90
Severus. *See* bishops.
*Shepherd of Hermas* 15
Sicilian Vespers, War of 64, 68, 84, 95

Sicily 10, 18, 63, 64; kingdom of (Regno of Naples) 55, 87
Siena, cathedral 80
Sorrentine peninsula 2
Sorrento 45; cathedral 61
Spaccanapoli. *See* vie: San Biagio dei Librai.
Spiritual Franciscans. *See* Franciscans, Spirituals.
*spolia* 4, 29, 45–46, 49, 56, 89–91
*stadium* x
Sta. Restituta. *See* churches: Sta. Restituta.
Stefania. *See* churches: cathedral, Stefania.
*stenopoi. See* topography and plan: *cardines.*
*stenopos–plateia. See* topography and plan: *cardo–decumanus.*
Stephen II 2
St.-Maximin-la-Ste.-Baume 87
*Storia di Napoli* 3
streets. *See* vie.
Swabians 55
Sylvester I, pope 24

T

Taranto, duke of 75
*Tavola Strozzi*, the 55, *(126–27)*
Teggiano 112
temples 49; Apollo 8, 28; Dioscuri 7, 8, *(7–8)*, 43
tertiaries 100
theaters x, *(8)*
Tiberius, emperor 7
Tino di Camaino 81, 82, 83, 92, 104, 109
tombs 5, 14–15, 18, 20, 21–22, 25, 39, 75, 93, 111–12;

# INDEX

Angevin *(78)*, 81–84, *(83)*, 92, 95, 104, 105, *(105)*, 107, *(107)*, 108–9, *(114)*. See also catacombs.

topography and plan ix, x, *(1)*, *(6)*, 42, 49–52, 106; ancient x, 1–12; Byzantine xi, 2; ducal 41–46; Angevin reconfiguration x, 98–112; capital 84–98; *cardo–decumanus* x; *cardines* 6; *decumanus*, upper 6; *decumanus*, lower 6, 43, 49, 52, 102; *decumanus*, major (middle) 6, 8, 26, 43, 45, 46, 59; grid plan x, xi, 2, 4, *(6)*, 7, 9, 49; lack of continuity x; material form x, 1–12; pozzolana 1; tufa platform x, 1, 12–13; *Risanamento* 53

Tunis 63

Tuscany 62, 64, 75, 100; influence 80–84, 106, 108; artists x, 80–84, Sienese 80

## U

Umbria 100; artistic influence 83, 94

University of Naples 57, 58–59, 62

## V

Valentinian III, emperor 10
Vandals 18
Vatican Library 105
Vesuvius 1, 12
via Appia 12, 59, 62
via Latina 62
*vici. See* topography and plan: *cardines.*

vie
  Anticaglia 6. *See also* topography: *decumanus*, upper.
  Benedetto Croce 102
  Carbonara 6
  Costantinopli 6
  dei Tribunali 6, 26, 43, 44, 45, 49, 54, 59, 88, 98. *See also* topography: *decumanus*, middle.
  del Duomo 26, 43, 95
  delle Corregge 95, 111
  Medina. *See* vie: delle Corregge.
  Mezzocannone 43
  Pisanelli 6
  San Biagio dei Librai 6, 49
  Vicaria Vecchia 6, 43. *See also* topography: *decumanus*, lower.

villas, ancient 9, *(9)*, 41; medieval 54

Vitolo, Giovanni 57, 65

Vomero 84, 105

## W

walls x, xi, 4, 6, 9, 20, 51, 57, 58, 86, 106; Greek 5, *(5)*; late Roman 10

War of the Vespers. *See* Sicilian Vespers, War of.

wharfs of Septimius Severus and Caracalla 10

William I, king 4

World War II 14, 68; Allied bombardments of 1943 52, 104; destruction of archives xii

■

This Book Was Completed on December 31, 2010
At Italica Press in New York, NY. It Was Set in
ITC Giovanni and Adobe Charlemagne.
This Print Edition Was Produced
On 60-lb Natural Paper
in the USA, UK
and EU

∎

www.ingramcontent.com/pod-product-compliance
Lightning Source LLC
Chambersburg PA
CBHW030743180526
45163CB00003B/903